JOSEPH BEUYS AND THE CELTIC WORLD

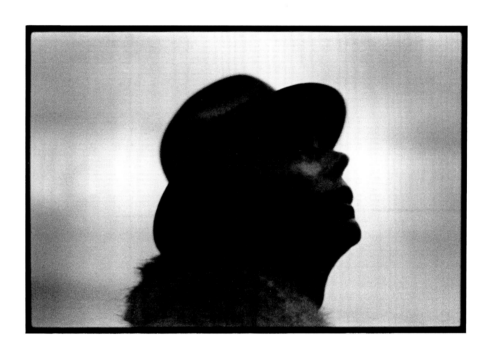

SEAN RAINBIRD

Joseph Beuys and the Celtic World

Scotland, Ireland and England 1970–85

TATE PUBLISHING

First published 2005 by order of the Tate Trustees
by Tate Publishing, a division of Tate Enterprises Ltd,
Millbank, London SW1P 4RG

www.tate.org.uk/publishing

British Library Cataloguing in Publication Data
A catalogue record for this book is available from the
British Library

ISBN 1-85437-590-3

Distributed in the United States and Canada by Harry
N. Abrams, Inc., New York

Library of Congress Cataloging in Publication Data
Library of Congress Control Number: 2004111466

Designed by Dalrymple
Printed by EBS, Verona, Italy

Front cover: Joseph Beuys on the Giant's Causeway,
Northern Ireland, photographed by Caroline Tisdall

Back cover: Joseph Beuys and Jimmy Boyle, 1982,
photographed by Richard Demarco

Frontispiece: Joseph Beuys photographed
by Caroline Tisdall

Contents

Preface

This publication coincides with the arrival of a major Joseph Beuys exhibition at Tate Modern. It builds on the Gallery's commitment to the artist in recent years. For Beuys's art has been a fixture in Tate Modern displays since the Gallery opened in 2000. Indeed, during one year, 2002, four of 60 galleries for the display of the collection were dedicated to Beuys. They included large installations such as *The End of the Twentieth Century* 1983–5 and *Lightning with Stag in its Glare* 1958–85, and smaller sculptures and blackboards. They were installed in the singular, spectacular double-height gallery at the west end of the building. Neighbouring galleries were occupied by *Bits and Pieces* 1957–85, a rich body of objects, drawings and multiples compiled over a decade by the artist for the writer and filmmaker Caroline Tisdall. Numbering around 300 items *Bits and Pieces* constitutes a comprehensive lexicon of the artist's materials and ideas. Having been shown first in London in 1976, while the collection was still being formed, this was the first time the complete ensemble had ever been shown in the capital. Tisdall discusses its formation and significance in an interview conducted during the installation at Tate Modern and published here for the first time.

Most major international museums, including Tate, began collecting Beuys's work late. The organic nature of many of his materials accounts for some of this tardiness, but is insufficient as an excuse. The fragility of many works, large and small, probably now precludes the possibility of assembling a comprehensive retrospective, so the importance of significant private and public collections on view to the public in museums and galleries gains in value now more than ever. The history of Beuys in Britain and Ireland, based on documentary sources and the recollections of his friends and collaborators, is the subject of this book.

Acknowledgements

Many people have shared with me their recollections about Beuys, but none with greater generosity than Richard Demarco and Caroline Tisdall, the twin axes of Beuys's activities in Scotland, Ireland, Ulster and England during the 1970s and 1980s.

I would also like to thank Judy Adam, Joan Bakewell, Eva Beuys, René Block, Timothy Emlyn Jones, Mark Francis, Richard Hamilton, Sally Holman, Bernd Klüser, John Latham, Mia Lerm-Hayes, Alexander and Susan Maris, James Marriott, Robert McDowell, Gustav Metzger, Richard Morphet, Sandy Nairne, the late Paul Neagu, Anne and Anthony d'Offay, Norman Reid, Norman Rosenthal, Roland Rudd, Shelley Sacks, Adrian Searle, Nicholas Serota, Johannes Stüttgen, Simon Wilson and John Wyver for help in my research. For assistance with archival and documentary information my gratitude goes to Ann Simpson at the Scottish National Gallery of Modern Art for showing me the Demarco Archive and photographs taken by George Oliver; to Krzysztof Cieszkowski, Alan Crookham and Adrian Glew of the Tate Library and Archive and to Suzanne Cotter at Modern Art Oxford. The late Dorothy Walker's unpublished manuscript about Beuys's activities in Ireland has been invaluable. At Tate Publishing I would like to thank my editor Nicola Bion, head of production Sophie Lawrence, copyeditor Mary Scott, and Robert Dalrymple for his handsome design; also Roger Thorp and Celia Clear for seeing the potential in such a book in the first place. I would like to thank Richard Demarco, Nicholas Serota, Rachel Taylor and Caroline Tisdall for reading the manuscript and making useful suggestions. Finally, for general support and good advice, I would like to thank Mieke Chill.
SR

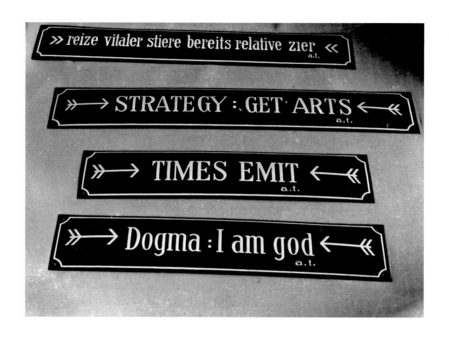

Andre Thomkin's palindromes, one of which became the title of an exhibition in Edinburgh in 1970

Introduction

Joseph Beuys's work and life have been so thoroughly covered by the media, the specialist art press and exhibitions, that one might question the need to cast light on any part of his career. However, there are some areas that have remained in the shadows. Such is the case with his activities in Scotland, Ireland, Northern Ireland and England during the 1970s and early 1980s. This important chapter in the artist's life is well known to his friends and collaborators, who still have vivid recollections: the object of this study is to bring it to wider attention. Fortunately, the general public is now accustomed to seeing his art more regularly in London and Edinburgh. The Scottish National Gallery of Modern Art recently purchased a major group of his multiples: these give a panoptic view of his ideas through the artist's expansive conception of the scope and substance that an editioned work can have. In London Beuys's art has had a permanent presence in Tate Modern's displays since the Gallery's inauguration in 2000.[1]

This celebratory response to Beuys, especially in Britain, is relatively recent, beginning in the last fifteen years of his career. Beuys came to national attention only in his forties, with international acclaim, and notoriety, following a little later. This he achieved through his participation in the Fluxus festivals in his native Rhineland during the 1960s, and after his first contribution to the five-yearly Documenta exhibitions in Kassel, Germany, of recent trends in art, at Documenta 4 in 1968. After this first appearance in Kassel he became something of a keystone at successive Documentas, culminating in the posthumous tribute to him at Documenta 8 in 1987. By the time Beuys showed his *Secret Block for a Secret Person in Ireland* 1936–72 in Oxford in 1974,[2] a hitherto largely unexhibited hoard of 266 drawings dedicated to an unknown, unnamed person and given that name on this occasion of the work's first exhibition, he was becoming known for larger-scale sculptures such as *The Pack* 1969. These contrast with the essentially private explorations of subject matter and ideas in his drawings and smaller sculptures, frequently relics of his actions, which marked his earlier primary activities during the 1950s and 1960s.

By the beginning of the 1970s Beuys was beginning to exhibit internationally, particularly in Scotland and Italy. His trips to America followed soon after, an

important new market, as well as a cultural landscape in which every ambitious European artist wished to establish his or her presence. Indeed, Anthony d'Offay, who first showed Beuys in the summer of 1980, suggested that the artist's exhibition at the Guggenheim the previous year was the first moment since the 1950s that European art contested the pre-eminence of the American, particularly New York, dominance of the art world. D'Offay noticed the unaccustomed sound of German being spoken at the Guggenheim's private view.[3] He recalled seeing Beuys standing just above the fountain on the slope of the first ramp, greeting collectors but also the many American artists, such as Lawrence Weiner, whom he knew from their exhibitions at progressive European galleries such as Wide White Space in Antwerp, and Konrad Fischer in Düsseldorf. This moment, d'Offay suggested, marked a shift in consciousness towards the claims of a European avant-garde, predominant among whom were Italian painters such as Enzo Cucchi, Francesco Clemente, Sandro Chia, and their German counterparts Anselm Kiefer, Georg Baselitz, Gerhard Richter and Sigmar Polke. Julian Schnabel, the most celebrated New York painter of the early 1980s, recalled the impact Beuys had in America, as well as on his own painting: 'there is a real break that Beuys made with a kind of American chauvinism and Greenbergian modernism, and art about technique. When paintings in a sense almost operate like sculptures, or like props that signal each other to get you into some sort of state that's outside of them, rather than just being part of a series of works with a similar appearance. Which is very different from formal sculpture or modernist sculpture.'[4]

It is well known that Beuys did not travel to America until after the Vietnam War, out of protest against the country's involvement in Vietnam.[5] He first went there in early 1974, on a lecture tour of several cities, including New York, Chicago and Minneapolis, and returned in May the same year to perform *I Like America and America Likes Me* (also known as the *Coyote* action). In this three-day action Beuys shared an enclosed room, René Block's New York gallery space, with a coyote. They were visible from one end of the gallery through wire mesh. Two weeks later Beuys performed his *Three Pots* action at the Poorhouse in Forrest Hill, Edinburgh. These were, in fact, the two final actions in which he used his own body in a performative way as the creative instrument. A more direct use of speech and language through dialogues, disputations and lecture-actions superseded these other kinds of action. Beuys's awareness of recent developments in American art is seen in collaborations such as *The Chief*, an action that occurred in Copenhagen in 1964. It was shortly afterwards reprised in Berlin, together with Robert Morris in New York. Although geographically separated, the two artists remained in simultaneous aural communication over the nine-hour duration of the action. Sculptural allusions to Minimal art can be seen in such geometrically structured works as Beuys's *Fat Up to This Level* 1971. By then critical writing about Beuys in English had begun to appear.[6] Only a few years before, indeed until the late 1960s, critical responses were almost exclusively in German, with Beuys's most eye-catching ventures taking place in the Rhineland. Although the Rhineland was one of the liveliest places for contemporary art at this time, Beuys's art was accessible only to part of the art community. He returned to the United States several more times, including a trip to New York to install the most

important retrospective of his work during his lifetime. Staged at the Guggenheim in 1979, it was conceived by Beuys and Caroline Tisdall in a sequence of regular conversations in which the content of the exhibition, its spatial organisation and the detailed commentaries in the catalogue were discussed, developed and recorded.[7] By the time of this retrospective, accompanied by a seminal catalogue which, like the installation, divided his life and work into a series of 'stations', a highly visible public image had emerged. This persona, and the presence of the artist within his works as performer and installer, was as much animated as defined by the grainy black and white photography, principally by Ute Klophaus, of his sculptures and actions.

However eye-catching Beuys's activities in America and Italy were, it is nonetheless more than a little surprising that his activities in the British Isles are passed by in the literature with such brevity.[8] This is the pattern in most general books about Beuys. The English-language edition of *Joseph Beuys: Life and Works* by Götz Adriani, Winfried Konnertz and Karin Thomas (first published in 1973), revised and translated in 1979 on the occasion of the São Paulo Biennale, is structured as an annotated chronology. Although detailed, it does not aspire to be definitive. Inclusions as well as omissions have thus shaped the way in which Beuys's international impact has been understood. The first, and principal, mention of Beuys in Britain in the book is his participation in the group exhibition *Strategy: Get Arts* at the Edinburgh College of Arts (24 April–12 September 1970). For some visitors, including regulars to the Edinburgh Festival during the 1970s and 1980s such as the broadcaster Joan Bakewell, the exhibition had a profound impact as much for the art exhibited as for drawing attention to the almost total absence of European avant-garde art in Scotland up to that point.[9] Particular notice is paid to the action Beuys performed several times over consecutive days between 26 and 30 August. *Celtic (Kinloch Rannoch) Scottish Symphony*, first performed in Edinburgh, was reprised as *Celtic + ∼∼∼∼* in a modified, longer version, and before a much bigger audience, in the Civil Defence rooms in Basel the following year (6 April 1971). Both versions of the action were documented in an extensive series of photographs published in the journal *Interfunktionen*. The photographic documentation for the Scottish performances contains, in addition, notebook jottings of the action's running order by Beuys's student Johannes Stüttgen.[10] There has been a tendency, though, to focus more on the later manifestation of this action. This is probably because of two sequences Beuys added to the action in Basel: a prefatory footwashing of seven members of the audience and a quasi-baptism at the end of the action. Both shifted the meaning towards a more overtly Christian iconography, rather than the paganist ritual of the Edinburgh version.

In Adriani, Konnertz and Karin's chronology, we encounter Beuys in Britain and Ireland on two further occasions: at the Tate Gallery and the Whitechapel Art Gallery in London, on consecutive days in February 1972, giving an *Information Action* (also described as an *Action Piece*), in which he lectures on, and engages his public in a dialogue about, political structures and social questions in relation to art. The final mention is the first exhibition in Oxford in 1974 of *Secret Block for a Secret Person in Ireland*. The show travelled from Oxford to Edinburgh, London,

Belfast and Dublin; Beuys was particularly pleased to be the first contemporary artist to have an exhibition that travelled to both parts of Ireland.

In another book in English translation, Alain Borer's *The Essential Joseph Beuys* (London 1996), the author includes a brief chronology, but gives no mention of Beuys's activities in Britain. The only clue to his presence there comes in a series of plates in the section entitled 'After the Academy'. This includes photographs of two environments, *dernier espace avec introspecteur* 1964–82, its second, and expanded, showing after the first installation at the Galerie Durand-Dessert in Paris, and *Plight* 1958–85, both as installed at the Anthony d'Offay Gallery in London. In his introduction, Borer mentions the Tate lecture-action in 1972 and, further, cites Beuys's preoccupation with Celtic mythology. By no means an exclusively British phenomenon, the pan-European existence of pockets of Celtic culture, history and archaeology enjoyed one of its periodic revivals during the 1970s, culminating in a major conference in Canada in 1978. Celtic history, artefacts and culture were addressed across a broad spectrum: topics at the conference included current perspectives on culture and on Irish

Blinky Palermo working on his wall painting, Strategy: Get Arts, *Edinburgh College of Art, 1970.*

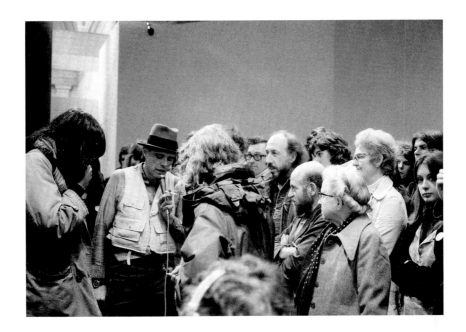

nationalism. Such brief mention by Borer and other authors is, nevertheless, a signpost for Beuys's activities in the British Isles, even though Borer conflated Beuys's interest in Celtic history and legend with his wider absorption of Norse and other Northern European cultures.

In Britain, as elsewhere, Beuys responded in the first instance to people attracted by his personal charisma and ideas, and by his inventive use and configurations of multiple kinds of materials.[11] Richard Demarco – the Edinburgh-based gallery director who had been invited by Peter Diamand, Director of the Edinburgh Festival, in 1967 to organise exhibitions of contemporary art – recalled first encountering Beuys at Documenta 4 in 1968. Demarco, who was accompanying the Chilean sculptor Edgar Negret, was immediately transfixed while observing Beuys preparing his installation. Two years later he finally met Beuys at the artist's home in Düsseldorf. He invited Beuys to Scotland, then at the periphery of engagement with contemporary visual art. Probably responding to Demarco's irresistible vitality and enthusiasm, Beuys agreed. They parted with Beuys (mis)quoting the witches' lines from Shakespeare's *Macbeth*: 'When shall we two meet again, in thunder, lightning or in rain?' This immediate identification with the emotional temperament of the country's culture was wholly in character. A year later, when Beuys arrived by train in Naples, at the invitation of Lucio Amelio, he recounted to the Italian gallerist, with whom he went on to make several important projects, his renewed reading of Goethe's *Italian Journey* (1786–8) about the poet's travels in Italy in the late eighteenth century. Beuys not only made a conscious analogy to his own trip to Southern Europe, emulating his famous German forebear who visited Naples after leaving Sicily. He was also retrieving something in his past by retracing some of the footsteps he himself had taken in Italy in 1943 while in the German armed forces.

Beuys during his lecture at the Tate Gallery, February 1972.

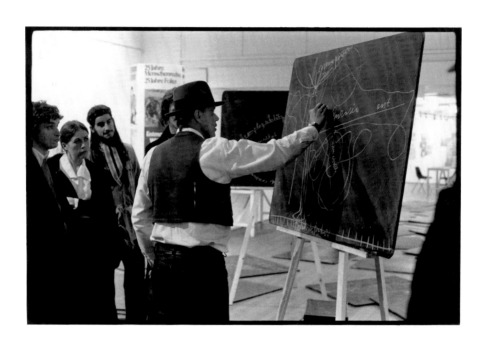

Beuys making one of the blackboards for Directional Forces *1974–7 at the* ICA, *London, November 1974.*

England

While Demarco was the principal motivator for Beuys to visit Scotland (eight times between 1970 and 1981), Caroline Tisdall, then art critic of the *Guardian* newspaper, and introduced to Beuys by Demarco in 1973 at Edinburgh's Waverley railway station, was his principal contact and travelling companion for his activities in the UK and Ireland. These were years not only of exhibitions, but also of Beuys's strenuous efforts to establish a permanent base for the Free International University (FIU), which he had announced in 1972 in a newspaper declaration in collaboration with the German author Heinrich Böll. Indeed the welcome Beuys received and the interest he encountered in Britain during the years after his dismissal from the teaching post he held at the Düsseldorf Academy of Art in 1972, years when he travelled extensively, encouraged him to make one last addition to the *Life Work/Course Work* autobiographical document he compiled, which fused elements of his life and career. It was frequently republished after its first appearance as a typescript in a Fluxus programme in 1964, then in expanded form in the catalogue of his 1969–70 Basel exhibition of a comprehensive group of works acquired by the collector Karl Ströher. The exhibition travelled to Eindhoven and is now permanently installed in the Landesmuseum Darmstadt. By 1969 Beuys had largely concluded this unusual listing which began with his 'Cleves exhibition of a wound drawn together with plaster', signalling the severing of his umbilical cord in 1921. He ended it with an extensive list of exhibitions and projects made between 1964 and 1969. Adding '1973 Joseph Beuys born in Brixton', he referred to the renewal of energy and new friendships that sustained his activities in the British Isles. This addition to *Life Work/Course Work* first appeared in the catalogue he and Tisdall prepared for the 1974 Oxford exhibition of his drawings, *Secret Block for a Secret Person in Ireland*. He retained the new entry when *Life Work/Course Work* was reprinted in the Guggenheim catalogue five years later. Indeed, such was his fondness for Brixton, Tisdall's base in London, that he also inscribed one of the posters advertising the 1974 showing in Edinburgh of documentation of his *I like America and America likes me* action with the dedication 'from the poor Brixton Boy'.[12] Robert McDowell, with whom Beuys worked while trying to establish the Free International University in Dublin, went further. He described the UK and

Ireland as a 'comfort zone' for Beuys after his dismissal from Düsseldorf, and a place to which he came to be challenged and inspired by people such as Richard Demarco.[13]

Before Beuys's and Tisdall's journeys and close collaborations on projects, which culminated in Beuys's Guggenheim exhibition at the end of the decade, the artist Richard Hamilton was, according to Tisdall, the conduit for many of those in England interested in learning more about the German artist.[14] Hamilton had seen Beuys's exhibition in Eindhoven, where Beuys was shown in parallel with Robert Morris. Hamilton was immediately made aware of the difference between post-war art in Europe and America. Looking at works made from felt by each artist in the entrance hall (before the exhibitions continued separately down

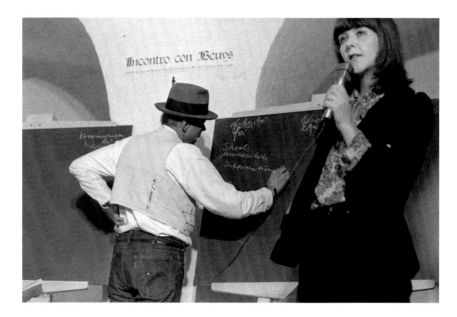

wings either side of the entrance hall) he noted, 'the twin personalities were bared. The American cool, thoughtful, abstract, minimal. The German white hot, visionary, arcane, multi-referential.'[15] Being so near the artist's home in Düsseldorf, Hamilton and his partner Rita Donagh rang his doorbell to pay their respects. From this visit developed a long friendship. Individual curators, especially Norman Rosenthal, first as Exhibitions Organiser at the ICA in London, later as Exhibitions Secretary at the Royal Academy, worked with Beuys on exhibitions in London galleries and museums. Early in his career Rosenthal invited Beuys to contribute to *Art into Society – Society into Art* at the ICA in 1974, for which Beuys made *Directional Forces* 1974–7. Indeed, within the at times insular world of British art, Rosenthal's knowledge of German had secured him his job at the ICA. He heard about the opportunity from Lindy Dufferin while both were attending one of the early 'Alternative Miss World' pageants, organised then as now by the artist Andrew Logan. Dufferin was looking for a German speaker to take forward plans for a 'German month'. Rosenthal was given a small sum of money to travel round Germany, as well as an introduction to Christos

Joseph Beuys and Caroline Tisdall giving a talk in Pescara, Italy, 1977.

Joachimides, who had just organised an exhibition in Hanover called *Art and the Political Struggle*; this became the template for the ICA's show and featured many of the same artists.[16]

Beuys installed in Britain for the last time when assembling a room for the exhibition *German Art in the Twentieth Century: Painting and Sculpture 1905–85*, organised by Rosenthal, Joachimides and Wieland Schmied, at the Royal Academy. In parallel with this exhibition he installed *Plight* 1985 at the Anthony d'Offay Gallery. At the RA Beuys was the only artist given a solo room, in which among other sculptures he installed the lightning element of his final sculpture *Lightning with Stag in its Glare* 1958–85. Rosenthal, when looking for financial backing for his exhibition, benefited from a chance meeting with the German

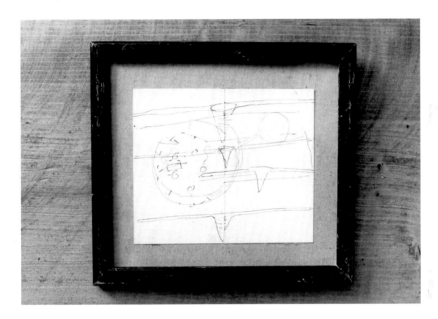

Chancellor Helmut Kohl, who happened to be dining at the same restaurant in Berlin. His agreement to become the exhibition's patron helped the RA gain financial support from other quarters. Kohl, who later accompanied the British Prime Minister and his co-patron Margaret Thatcher through the exhibition, was heard to say, to her obvious bemusement, 'Maggie, Maggie, come over here – this is Joseph Beuys, famous German artist.'[17]

Nicholas Serota, while Director at the Museum of Modern Art in Oxford (1973–6), built on the relationships between his own staff and Demarco, some of whom had formerly assisted Demarco in Edinburgh, as well as exhibition collaborations between the gallery and Demarco, which had begun with an exhibition of Italian art Demarco organised that travelled to Oxford in 1967. While at the Arts Council at the beginning of the 1970s, Serota had proposed a Beuys exhibition for London's Hayward Gallery, and met the artist to discuss his ideas when Beuys lectured at the Tate Gallery in February 1972. Beuys, according to Serota, was very interested in doing a show in England, having already shown in Scotland. Discussions about bringing Beuys to London had already taken place in 1970

A small sketch showing a possible environment for the rotunda at the Tate Gallery.

between Demarco and Michael Compton, Head of Exhibitions at the Tate, when Demarco aspired to tour *Strategy: Get Arts* to London. Although nothing came of the idea conversations continued between Beuys and Compton. Although the initial result was an invitation to do a project at the Tate in 1972, which included his lecture-action, Beuys continued to note ideas for using galleries at the Tate for an environment. His idea for a group of sculptural elements in the central octagonal Duveen Galleries at the Tate is depicted in the drawing *Environment for the Tate Gallery* 1971–2, in *Secret Block …* For this Beuys used a gallery floor plan supplied by Compton.[18] In a small sketch in *Bits and Pieces* made a little later, in 1975, Beuys returned to the idea of an installation at the Tate Gallery. This time, however, he proposed a series of filters suspended in the rotunda at the entrance to the gallery.[19]

Sadly, these sculptural interventions remained unexecuted, but Beuys's presence at the Tate in February 1972 was widely reported. Over a two-week period (24 February–6 March), Beuys showed videos of his previous actions, as part of a swiftly assembled season of contemporary shows called *Seven Exhibitions*. Beuys was the only artist from outside Britain to be invited. The main part of his presentation was a lecture-action which lasted over six hours one Saturday. Among those discussing his ideas and proposals was his friend Richard Hamilton and the German-born (now stateless) artist Gustav Metzger. With artists' talks still a relatively new phenomenon in museum life, the critic Guy Brett, writing in *The Times*, mused on whether he had witnessed an exchange of views or a performance: 'He invited questions. But the main question in people's minds seemed to be whether what was taking place was an open inquiry into Beuys's utopian proposals, or a kind of performance in which everyone unwittingly took part.'[20] Beuys could not have signalled more clearly his intention of viewing art as part of a social process when he wrote on one of three blackboards used during this talk about hunger afflicting two-thirds of the global population, while people in the West took slimming pills. This, Beuys challenged, went to the core of people's humanity.[21] These themes remained throughout the 1970s, in his *Honeypump* discussions lasting a hundred days at Documenta 6 in 1977, and in the programme of the Free International University, which included discussion of the Brandt Report, at Edinburgh in 1980.

Although his Hayward proposal faded, Serota took the idea of working with Beuys to Oxford when he became Director at the Museum of Modern Art in 1973. That autumn he and Tisdall discussed the idea of showing a group of drawings the artist had held back, which Beuys viewed as something of a key to his practice. The gallery closed temporarily for renovations and repairs at the end of that year. When Beuys arrived in Oxford in his Bentley early in 1974, with the drawings in the back of the car, Serota was faced with the possibility that the exhibition might not take place as Beuys became anxious about dampness caused by a leaking roof. He instituted a test, placing a piece of paper in a frame and saying that, should it have cockled on his return to hang the exhibition two weeks later, he would have to withdraw. Fortunately, the dampness abated and the show happened. Serota recalled Beuys taking the test piece, hung from a thread affixed to the corner of the frame, and writing the words 'damp value' on top of the moisture stains.

When it came to installing the exhibition Beuys wished to avoid the double and triple hanging of blocks of drawings, and evolved a simple solution for the large upstairs gallery using decorators' trestle-tables. By joining trestles together he created one long table down the centre of the space, about 15 metres long and 2.5 metres wide, on which he placed drawings, so creating a form of sculptural installation of his drawings.[22] Comment was made about Beuys's choice of Gothic lettering for the cover of the catalogue. Serota suggested that this was perhaps inspired by Beuys's inclusion in *Secret Block* … of some very early drawings, some of which were quite formal botanical studies, that reminded him of his botanical studies from his German schooldays.[23] Tisdall, who had studied German literature and who designed the catalogue, confirmed that it was in fact she who elected to use the Gothic typeface.[24]

In the final decade of the artist's life up to his death in 1986, Beuys's commercial representation in London was strengthened by a steady series of significant exhibitions at the Anthony d'Offay Gallery. Since 1965 Anthony d'Offay had been dealing principally in early Modern British art: the Vorticists, Stanley Spencer, Bloomsbury and Camden Town. Following his marriage in 1977 to Anne Seymour, formerly a curator at the Tate Gallery, they decided to shift the emphasis of the gallery to bring international exhibitions to London. Their intention was to attract to London Europeans who would encounter American art, and to bring American artists of interest to European museums and collectors. D'Offay set out to interest key figures of the British art world in Beuys's art. They included the critic and curator David Sylvester, who attended several small dinners when Beuys was visiting London.[25] D'Offay had high ambitions for the gallery, one of which was to remain financially independent from the outset. Beuys, whose work Anne Seymour had followed since the 1970s, and whose Guggenheim exhibition in 1979 confirmed to Anthony d'Offay his critical role in contemporary art, was pursued with an invitation to inaugurate the exhibition programme of the new gallery. This he did, with an installation called *Stripes from the House of the Shaman*.[26] D'Offay took a risk in preserving his independence by refusing backing for the gallery. His determination to succeed and the fortuitousness of his timing in re-orientating the gallery when he did, finally paid dividends during the fifth exhibition, when the Beuys installation was acquired, in January 1981, by the National Gallery of Australia. At one fell swoop d'Offay had demonstrated the international reach of the gallery. He recalled Beuys's excitement at going out to Australia soon afterwards to re-install the work in Canberra. Although the response from the Tate Gallery was to remain disappointingly muted, this first sale set the tone for future purchases by major museums across the world. During the late 1980s and early 1990s, *Lightning with Stag in its Glare* 1958–85 was sold to Philadelphia, and other major works went to the Guggenheim and the Hirschhorn. His work *dernier espace avec introspecteur* 1964–82, in an expanded version after its first showing in Paris, was sold to the Staatsgalerie Stuttgart, and *Plight* 1985 was sold to the Pompidou Centre in Paris.

One of the stranger meetings occurred during the *Plight* installation, when the National Union of Mineworkers' leader Arthur Scargill, then locked in battle against the Thatcher government and the National Coal Board, met the artist.

overleaf: Beuys lecturing at the Museum of Modern Art, Oxford, 10 May 1974.

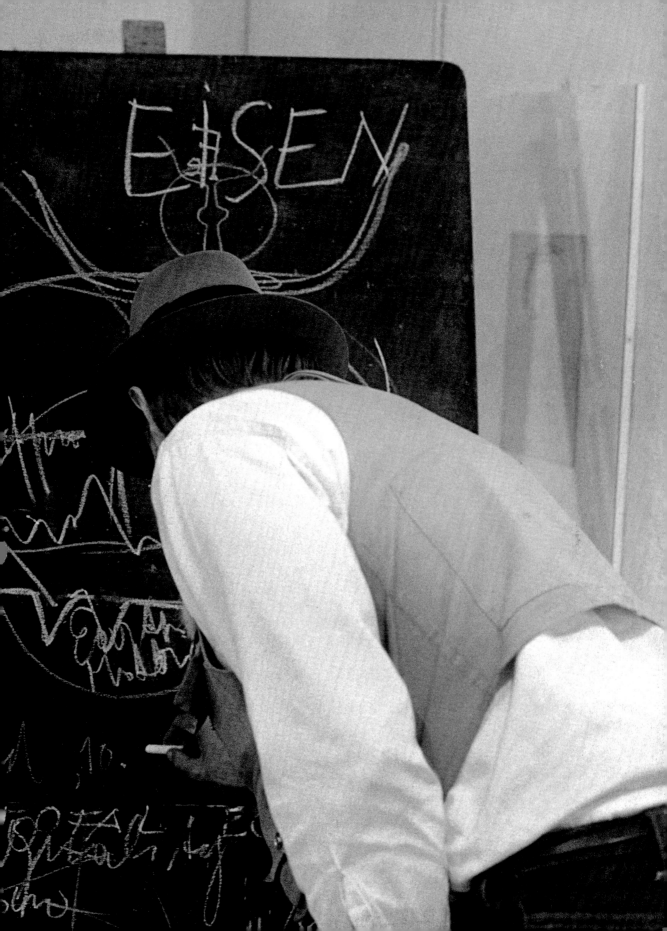

According to Judy Adam, then working with Anthony d'Offay, Beuys asked to meet Scargill. Tisdall recalls that Beuys wanted to ask Scargill why he wanted to see another generation of young men underground doing an anachronistic form of work, and why he was not arguing for them to be retrained for a different kind of employment.[27] The miners' leader could only visit the show in early 1986, after it had officially closed; his office informed the gallery that he was besieged with business connected with the strike. Scargill was asked if he would contribute to a BBC *Arena* programme on Beuys then being filmed, and Adam recalled that Scargill was careful to look at the work before giving his comments on camera. After their first meeting Scargill was intrigued to meet Beuys again, but Anthony d'Offay had to inform him that the artist had died a few days before.[28]

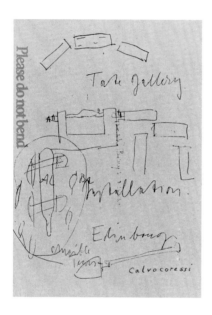

According to Serota, Beuys always harboured hopes that the works he presented in London after Anthony d'Offay opened his gallery in 1980 might be acquired by the Tate. Beuys's regular London shows at the Anthony d'Offay Gallery were probably the reason why the aspiration that Beuys and Serota had for an exhibition at the Whitechapel Art Gallery during the early 1980s came to naught.[29] Another cause for this omission was suggested by Anthony d'Offay, which was that Beuys always liked showing new work, preferring this to making retrospectives of his art. Eventually the Tate acquired two of a sequence of thirteen vitrines exhibited by Anthony d'Offay in 1983, although it could have acquired the complete group. Partly in order to rectify this, Beuys visited the Tate Gallery a year later, bringing two artist's proofs of recently cast sculptures. He then created a third vitrine in the style of the others by combining these recent casts with two works, one a gift to the Tate from the collector Ted Power, the other already in the collection.[30] A small sketch by Beuys on an envelope of the kind used by the gallery indicated how the three vitrines might be installed. In 1991, after Beuys's death, the Tate finally acquired a large-scale installation, *The End of the Twentieth Century* 1983–5.

Beuys's visits to the UK and Ireland throughout the 1970s and into the 1980s were regular occurrences. In 1974 they were at their most intense. That year he installed *Secret Block ...* in Oxford and in four other venues in Britain and Ireland, and visited the Giant's Causeway in County Antrim. He also performed the *Three Pots* action in Edinburgh in May, before returning there in the summer to participate in a conference and to see a photo-documentation of his *Coyote* action exhibited at the Poorhouse in Forrest Hill. He was in London later that autumn for the

duration of the *Art into Society – Society into Art* exhibition at the ICA (30 October–24 November 1974), although he had to travel back and forth to Belfast to install *Secret Block*... at Ulster Museum. During certain periods, particularly in the first half of each decade, he produced major works and installations. Many were shown in their earliest form; later they were modified, extended or adapted. This accorded with Beuys's methodology, which valued process and change over closure and permanence. A prime example is *Directional Forces* 1974–7, created during the four weeks of the *Art into Society – Society into Art* exhibition. In its final form, in the collection of the Nationalgalerie, Berlin, it consists of a hundred blackboards, most strewn across the ground, but with three boards on easels, plus an electric light. All of these elements are presented on a platform, raised from the

floor and thus removed from the immediate ground level shared with the visiting public.

The four stages of the transformation of *Directional Forces*, from work-in-progress to museological object, are here described in reverse order, to remove us from the work as we find it today back towards its origin. It shows Beuys's characteristic way of integrating the processes of making in an original context, as part of an evolution towards a finished sculpture. At the Biennale in Venice, pre-empting its final form within the collection of a museum, Beuys presented it as a museum work. Viewable from a doorway, which defined the angle of viewing, it was otherwise behind barriers and inaccessible to the public in the room in which he placed it. This took the installation away from the direct participation of the viewer, which was possible in its second viewing, in New York. There, the gallery visitors were able to walk through the work among the boards on the floor, but without otherwise intervening or changing its arrangement or content. This had followed the original making of the work, at the ICA in London, where Beuys drew on seventy-seven blackboards, then cast them on to the floor around him.

Beuys at Art into Society – Society into Art, ICA, London, *making* Directional Forces *1974.*

He made them over the course of the exhibition during a continuing dialogue he had with gallery visitors. Indeed, at this germinal stage in the work, visitors themselves also drew on the blackboards, or sometimes smudged or obliterated the existing words and images. Norman Rosenthal recalled Beuys requesting three or four school blackboards for his contribution to the exhibition. Beuys, like the other artists, proposed to be present during some or all of the exhibition. Through his contribution, which ultimately meant he was present throughout the twenty-four days of the exhibition, with the exception of a couple of previously arranged interruptions, Beuys utterly outstripped the contributions of the other six artists.[31] In part, at least, the reason was that Rosenthal had unearthed a trove of around a hundred blackboards, storing all but the three or four Beuys

had asked for at the ICA.[32] When Beuys discovered them, the course was set for a radical expansion of the material aspect of the idea he had first proposed. When Beuys had finished drawing on a blackboard, he would take it from the easel and hold it aloft before throwing it clatteringly to the ground. In the evenings, Rosenthal recalled, Beuys would order things a little and fix the boards using hairspray supplied by Rosenthal.[33]

In other instances, the original showing of a work, in its earliest form, could come to be occluded by the forceful presence of its final installed form. Such was the fate of *Arena* 1970–3, until a major publication dedicated to it appeared in 1994 and delved into its origins.[34] *Arena* is a predominantly photographic installation, with 264 photographs mounted in a hundred metal-framed panels. In the centre of the room they occupy, which Beuys has variously intended to be circular or four-sided, stand two piles of unevenly cut iron plates and an oil can. The photographs show Beuys's actions and works over a long period. His presence as the subject in many of them reinforces the cult of the artist as chief celebrant of his work. Before its acquisition by the Dia Art Foundation in New York, Beuys

gave *Arena* its final content and form over two exhibitions in Italy, first in Naples in 1972, then a year later in Rome. Initially consisting of 160 photographs mounted in simple clip-frames, it was first shown in *Strategy: Get Arts* in Edinburgh in 1970, in the context of *The Pack* and *Celtic (Kinloch Rannoch) Scottish Symphony*. Noting that it attracted little attention next to those other presentations – indeed it passed unremarked in the many critical responses to the exhibition – Lynne Cooke nonetheless proposed that Beuys would probably have attached importance to its presence in Scotland. The three works, taken together, formed 'his debut in the English-speaking world'.[35] Indeed they might be understood as a rounded introduction to his art for this new, important audience. *The Pack* suggested a means of survival in the desolate plains of Eurasia, the geographical land mass spanning the continents of Europe and Asia, thus referring to a cultural and spiritual spectrum that features so prominently in Beuys's thinking and art. *Arena* was a form of biographical introduction, while *Celtic…* was a live action in which Beuys responded, profoundly, to the Scottish environment he had found himself encountering. It was not only the presence of Beuys, but largely because of it, that Demarco, writing during the planning stage of the exhibition to Jennifer Gough-Cooper, who worked in his gallery, suggested that 'this whole show should be a happening – ten years ahead of anything in Britain including the ICA's efforts'.[36]

Perhaps it is unsurprising, bearing in mind the lack of response to such works as *Arena* during this exceptionally fertile period in his career, that Beuys's activities in Scotland, Ireland and England are so little acknowledged in much of the mainstream literature on Beuys. In *Joseph Beuys*, Heiner Stachelhaus's biography on the artist first published in 1987, the year after Beuys's death, the author included a chapter 'In Italy – In America', about Beuys's activities after 1970. As his visits to both those countries were contemporaneous with his presence in the British Isles, Stachelhaus made a brief comparison with Beuys's activities in Britain and Ireland, but without going into remotely as much detail. Beuys was involved in thirty-five projects and exhibitions in Italy between 1971 and his death in early 1986. While registering the scale of this involvement Stachelhaus acknowledged that Beuys's visits to Britain and Ireland were almost as numerous: Beuys visited Scotland eight times and exhibited sixteen times in London alone. Indeed, Nicholas Serota suggested that his visits to Britain and Ireland in the mid-1970s had a similar importance to those to Italy in the early 1980s. These took him to places far from the melting-pot of contemporary art. Once, in 1977, on behalf of the Free International University, Beuys exhibited in Wrexham, Wales, alongside Mario and Marisa Merz, Jannis Kounellis and others, as part of the Royal National Eisteddfod.[37] On another occasion, in 1974, faced with an audience of two nuns and a passer-by during a lecture in Limerick, Ireland, Beuys commented wryly to Tisdall, 'why have you dragged me off to the ends of the earth? Fame in the art world only extends so far!'[38] Aside from Italy, Beuys made more projects in the UK and Ireland than in any other country outside his German homeland. At times these British and Irish visits can be seen as a pendant to his activities in Italy, such as his extended reading of Anarchasis Cloots, first in Rome (30 October 1972), then in Edinburgh the following summer.

While connections between Beuys's projects both in the UK and Ireland and in

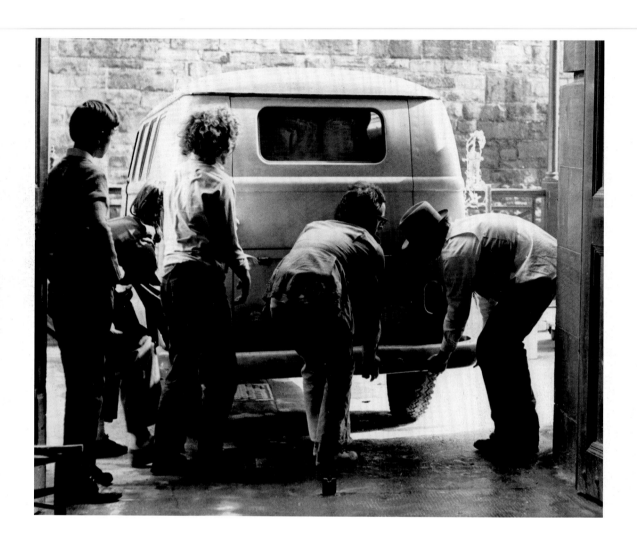

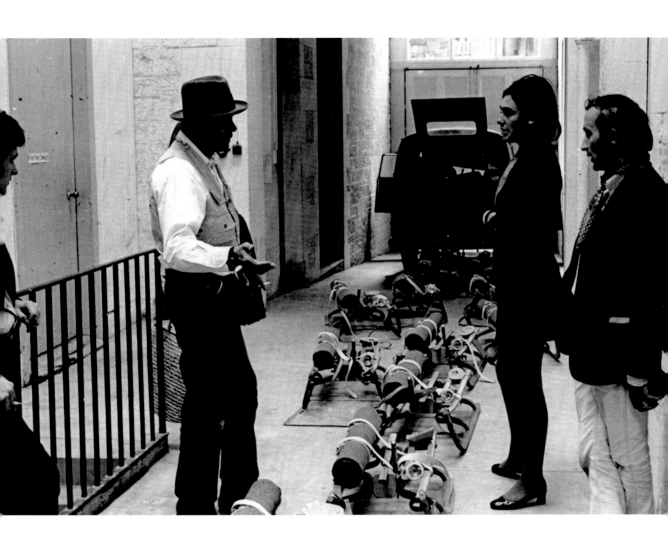

The Pack *1969, being installed at the* Strategy: Get Arts *exhibition, Edinburgh College of Art, 1970.*
Richard Demarco, the show's organiser, is on the far right, talking to the artist.

Italy existed, there were other, geographical, connections. Both England and Italy have a mountain chain named after Penninus, the Celtic deity, each of which divides the respective countries geographically and culturally, and each of which is described as the backbone of the country. Anne d'Offay suggested that Beuys was very likely to have been aware of the time in prehistory when Britain and Ireland were still part of the European land mass, thus enabling the migration of peoples but also of animals such as deer, elk and reindeer, the former still indigenous to Scotland and isolated parts of England.[39] The image of a mountainous backbone is central to the structure of Beuys's *VAL (Vadrec)* 1961, with its cast spine running along the hollow interior of the bronze sculpture. The Pennines in the north of England extend from Staffordshire to Cumbria. The Apennines in Italy join the Ligurian Alps at the Cadibone Pass in the north, and run 1,300 kilometers down the centre of Italy before ending at the Messina Straits at the southernmost tip of the peninsula; the mountains of Sicily are a continuation of the mountain chain.[40] The southern section of the Appenines is prone to earthquakes.

Mountains, from their mineral composition to their mythologies, were of enduring interest to Beuys. This fascination extended from their effect on climate to the deep time-scale of their formation, as well as the reappearance in isolated pockets across the earth of specific kinds of rock, such as basalt deposits in Iceland, Scotland and, closer to Beuys's home, in the Eiffel region of Germany. Mountains were the subject of numerous drawings and objects by Beuys, such as the volcanic eruptions represented in *Montanus and Macarius* 1951, in *Secret Block* ...[41] Minerals, whether sculpted by earthly processes or hewn by man in various forms, such as cobblestones, appeared in several of Beuys's works. For Beuys, mountains, on a vast scale, represented the skeleton of the earth. Their mineralised state was a sign of great strength and offered the 'potential regeneration of material'. He explored this theme in several drawings, including those in *Secret Block* ..., some symbolised by the Celtic god Penninus, whom Beuys viewed as 'the archetypal mountain spirit of the ridge which extends across Europe from the Pennines to the Apennines'.[42] *Bits and Pieces* includes *Penninus* 1975, a small drawing that directly alludes to this common thread. Moreover, by adding the (German) letters for 'transmitter' and 'receiver', Beuys refers to the energy emanating from those high places and natural forces that tie humans to the ancient processes forming the earth's crust. For Italy, Naples in particular, such images embodied the actual threat of earthquakes and volcanic eruptions, such as the major earthquake around Campania in 1980 in which 4,800 people lost their lives. The geological fragility of the earth's crust in southern Italy inspired several sculptures, in particular *Terremoto in Palazzo* 1981, with its shattered glass and time-worn workbenches balanced precariously on fragile glass jars. Beuys was probably aware that the extinct volcano Arthur's Seat, which dominates the Edinburgh skyline, was formed by a volcanic eruption some 400 million years ago.

These earthly eruptions formed a parallel with social upheavals Beuys observed and refracted through his work. In Italy the left-wing Red Brigade mounted a sustained assault on the body politic. Its activities climaxed in 1978 with the abduction and subsequent murder of Aldo Moro, the Italian Premier and leader of the Christian Democrat Party, after the Government refused to release thirteen

Red Brigade members on trial in Turin. During the 1970s several other European countries experienced extreme, politically motivated violence; nowhere more so than Northern Ireland. There, sectarian violence between Catholics, Protestants and the British Government, known as 'the Troubles', flared in intensity, particularly after the Bloody Sunday shooting of Catholic civilians by the British army on 30 January 1972. The title Beuys gave one of his drawings in *Secret Block...* before its first showing in Oxford, namely *The Most Dangerous Electrical Machine Gun*, BELFAST 1963, cuts to the quick of this political ill.[43] *Battery* 1974 is a work in *Bits and Pieces* consisting of a bundle of *Guardian* newspapers. It addresses the density and complexity of the passage of world events, embodied by the stockpiling over a short period of all the daily contents of a newspaper. This 'battery',

of all the papers awaiting Caroline Tisdall's return from a trip to Ireland (she was at the time art critic for the paper), has a carefully chosen uppermost, visible, page. Within this random cross-section of incidents and accidents, Irish politics comes to the fore. The bundle of papers is tied with twine, and *Braunkreuz* (a brown paint that was favoured by Beuys) has been applied over the twine to form a large cross. The horizontal and vertical elements of the 'Braunkreuz' cross, like the cross wires of a rifle sight, settle on the photograph of a male face. At first glance the man appears masked, but closer inspection shows that it is in fact gauze bandaging on the head of a young victim of an attack. To the right is a report on an Arab hijack. Above the photograph is part of a headline, '... tough laws against the IRA'. For all the other information about political, cultural and economic world events contained within the pile of newspapers, Beuys elected to draw attention to the political ills of the moment, in particular those in Ireland.[44]

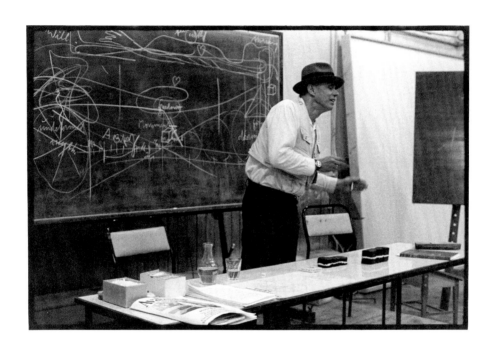

Beuys lecturing in Ireland with Irish Energies *1974 on the table in front of him.*

Ireland

Beuys's knowledge of events in Ireland was heightened by his visits there on several occasions during the 1970s and 1980s. The complexity and delicacy of the many apparently intractable issues appear in his work sometimes in subtle ways, such as in the small object *Northern Irish Tongue* 1974, which Beuys inserted into *Bits and Pieces*. It consists of the image Beuys used on the private view card for his New York action *I Like America and America Likes Me*. A negative image, it shows a ghostly impression of his head, taken by Ute Klophaus, in which he appears shot through the head. This is juxtaposed with a fragment of brick found in Belfast after an explosion; the shapes in its rough surface echo the outlines of Beuys's head in the photograph. The 'Irish Tongue' of the title plays on one of the many political and cultural groupings in Northern Ireland politics during this period, the term *Gaeltacht* (Irish tongue), which referred to the Irish-speaking parts of the North.

Northern Irish Tongue was one of the many groupings constituting *Brain of Europe*, which Beuys made the centrepiece of his installation *Hearth*, in its first manifestation in New York between 1968 and 1974. The discursive nature of Ireland's political culture was reflected in the installation, first shown untitled at the 1974 Basel Art Fair, then a year later as *Hearth* at the Ronald Feldman Gallery in New York. Blackboards in the installation were based on material Beuys had first lectured about in Oxford on 10 May 1974, towards the end of his exhibition there of *Secret Block* … In New York, Beuys made a copy of a drawing by Tisdall of Ireland on the floor of the gallery, appropriately enough on an actual hearth slab. Around the outlines of Ireland and as lines intersecting the country Beuys inscribed the names of the myriad political and cultural movements in Irish politics of the day. These included the main Union, Nationalist and Republican parties as well as the many splinter groups that adorned the Irish political landscape during the 1970s. Dorothy Walker, then art critic of the fortnightly journal *Hibernia*, speculated that by naming the many groups, 'what he had in mind may have been all the paradoxes inherent in the Irish turn of mind, including the love of paradox itself, which counteracts rigidity and over-reliance on theory. He admired the instinctive Irish reliance on ad-hoc solutions to problems, as a perhaps necessary

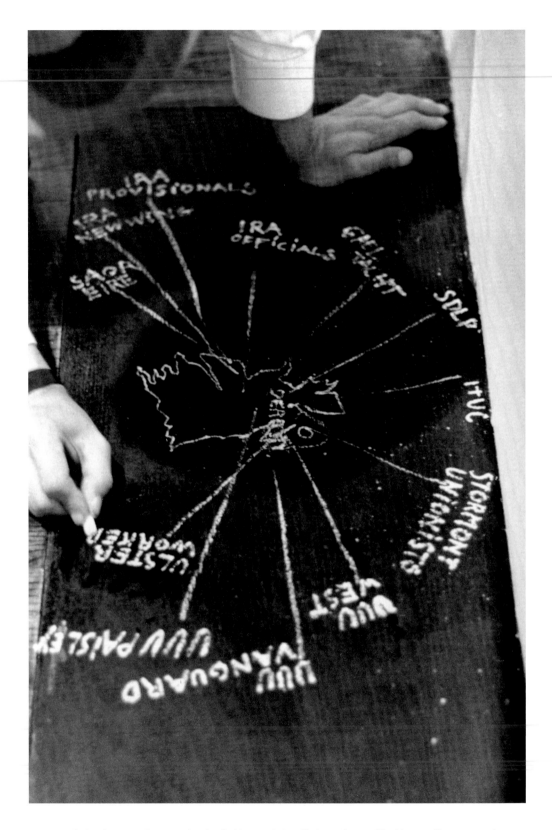

34 *Beuys completing the* Brain of Europe *drawing for his* Hearth *installation at the Ronald Feldman Gallery, New York, 1975.*

counterpoint to the organized efficiency of Germany.'[45] Not least of these paradoxes was that, for all the current political upheavals in the north, the Irish Republic had and retains a tradition of neutrality in international conflicts.

Beuys was drawn to movements of political dissent and attracted to areas of conflict as places needing healing. As an alternative path, he proposed dialogue as a means of resolving differences. These countries at either end of Europe, Italy, and Ireland and Britain, provided him with a focus outside Germany, which itself was in the grip of political upheaval in the conflict between the Red Army Faction and the German State. At Documenta 6 in 1977, Beuys created a programme of discussion on a broad range of topics discussed in many languages, over the hundred-day duration of the exhibition. These included, between 22 and 31 August, workshops on Northern Ireland, bringing together not only artists and writers, but also singers, scientists, economists and politicians. They included a residents' group from Ballymurphy, whom Beuys had met in Belfast while on a visit there in 1974. During that first visit they had expressed their difficulty in following his ideas. Dorothy Walker later recalled that 'he was disconcerted by the very vigorous questioning he received about his education ideas from members of the Ballymurphy community (a typically underprivileged Catholic district of Belfast living in poverty and discrimination) who felt that his proposals, couched in, to them, impenetrable language, were still elitist and not really democratic'.[46] Moreover, she reported, the community felt Beuys's ideas not to be so innovative, as their local priest Father Des Wilson was already offering open community classes at the local Conway Street Mill.[47]

The idea of embedding art within society was pursued by several artists at the time, including John Latham. Latham took part in the hundred days of Documenta 6 in 1977, discussing his concept of the incidental person with Beuys and other members of Latham's Artist Placement Group (APG). The APG was an undertaking through which Latham negotiated with companies and official departments for an artist to work in their midst. This direct involvement of artists in social enterprises resulted in a discussion in Bonn between the APG and ministers from Helmut Schmidt's administration, held at an exhibition called *APG: Art as Social Strategy*, which took place after the Documenta and ran from December 1977 to January 1978. This in turn led to a public disputation event at the exhibition between Latham and Beuys on 13 January 1978, billed as *Pragmatism versus Idealism*. Later, Latham recalled: 'I never found out quite who in the end was supposed to represent which and it didn't matter a lot because the audience was obviously there to watch the metagalactic apparition under the hat.'[48]

Pursuing the idea of redirecting people's energies towards constructive paths through education, Walker recalled an occasion when Beuys paid a lightning visit to Dublin, to attend a lecture given by Ivan Illich (1926–2002). In the 1970s Illich was a highly influential commentator on the institutions of Western society. He published a series of polemical works, including *Deschooling Society* (1973), in which he investigated the function and impact of the education system in Western society. In the existing system, Illich wrote, 'the pupil is thereby schooled to confuse teaching with learning, grade advancement with education, a diploma with competence, and fluency with the ability to say something new. His

imagination is schooled to accept service in place of value.'[49] Walker noted a similarity between Illich's views and those of Beuys, as addressed through the FIU. Each had 'equally subversive, although rather different, ideas about education, but both agreed on completely open access and disruption of a self-perpetuating status quo in both general and art education'.[50]

Throughout the mid-1970s Beuys, aided by Caroline Tisdall, Dorothy Walker and the artist Robert McDowell, made great efforts to establish the Free International University in Dublin, as a place from which to disseminate Beuys's ideas more widely in Britain and Ireland. Beuys had founded the FIU in 1972 at the time of his dismissal from the Düsseldorf Academy of Art. The immediate reaction from

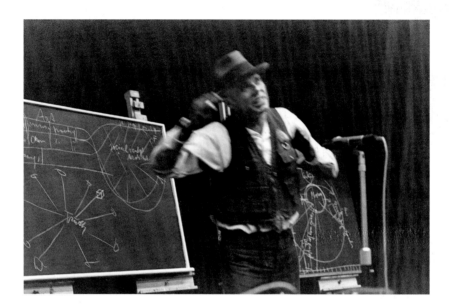

Dorothy Walker, who had just read the critic Georg Jappe's interview with the artist in *Studio International*, was to invite him to apply for the recently vacated directorship of Dublin's National College of Art and Design. When they finally met two years later, in September 1974, Beuys apologised for not replying to the invitation, saying that he never again wanted to become involved with a state institution after his experiences in Düsseldorf.[51] Nevertheless, he regarded Dublin as an ideal location for the FIU because he viewed Ireland as a place with conflicts in need of resolution. McDowell had been introduced to Beuys by Tisdall sometime in 1973, and recalled talking to the German artist about his own initiative in Ireland, the Troubled Image Group. Consisting of between forty and fifty politically engaged artists, the group attempted to address the Troubles, while recognising the added complexity of looking at current concerns that were 'under your feet', rather than, as with Vietnam, at some geographical and emotional distance.[52] Beuys expressed his pride in being one of the first contemporary artists to exhibit in both parts of Ireland, one way, through his art, of healing the social and political rifts he encountered there. His supporters

Beuys lecturing at the Magee Institute of Continuing Education, Derry, Northern Ireland.

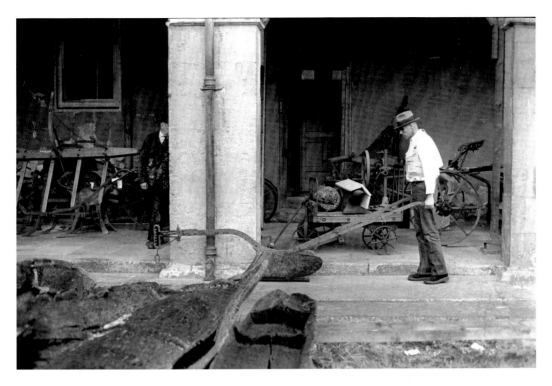

Kilmainham Hospital, now the Irish Museum of Modern Art, Dublin, was offered to Beuys in 1974 as a possible headquarters of the FIU.

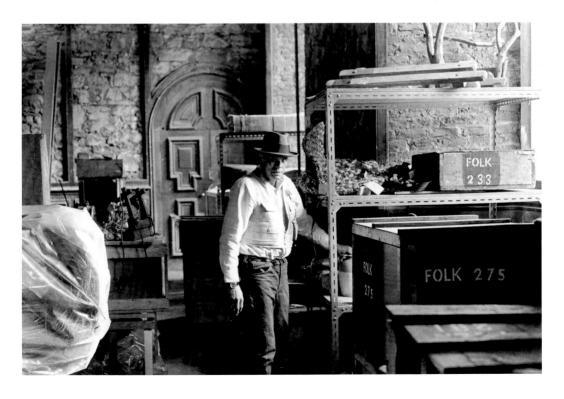

Beuys at Kilmainham Hospital, at that time a repository for the collection of folk art and implements.

identified a building in Dublin to serve as the headquarters for the FIU, and arrangements were advanced before the moment to realise the project finally slipped away.

In September 1975 Tisdall had compiled a feasibility study on the founding of the FIU for the EEC (revised with McDowell in 1976), which was commissioned by Ralf Dahrendorf, then Principal of the London School of Economics. The choice of Ireland as the location for the FIU was the subject of the report's second section. The small size of the country, Tisdall argued, would ensure that the contribution of the FIU would be felt within the community. She also referred to the underdeveloped state of the Irish economy as a positive platform, for the country to avoid 'the pattern of economic, social and cultural errors that has lead to crisis point in the highly developed countries. Ireland could be one place in Europe from which to analyse such mistakes, to avoid them, and to provide more practical, imaginative and democratic models for the future.'[53] Tisdall cited the more positive domestic response to Ireland entering the EEC, compared with Britain (both joined in 1973), arguing that Ireland's concern was for the future, not its 'Celtic Twilight'. However, this future development, she observed, 'cannot be restricted to economics without consideration of her particular cultural and historical experience'.[54]

Although these concerted efforts to establish the FIU in Dublin ultimately came to nothing, Tisdall and McDowell were the leading proponents of the FIU during the 1970s. They usually worked directly with Beuys, as in the FIU contribution to the Edinburgh Arts in 1980. Another group of artists and critics, inspired by the ideals of the FIU, carried the flame in the mid- to late 1980s. One of their number, James Marriott, recalled meeting Beuys in Cambridge in 1983, where the artist was lecturing at Kettle's Yard on the occasion of an exhibition of his drawings that subsequently travelled around Britain. Through others in Britain, mainly Tisdall and Demarco, Marriott was put in touch with FIU colleagues in Germany and, with other members of his group, visited many of the FIU organisations around the country, in Kassel, Achberg, Düsseldorf and Stuttgart.[55] On their return to the UK and with few funds at their disposal, Marriott and his colleagues set up an itinerant university following the ideals of the FIU. Structured as an open forum, it met in peoples' homes or in colleges, in Glasgow, Sheffield, Bristol and London. The culmination of its activities came in the late 1980s; first in 1988 in a rolling programme of discussions and performances held over seven days in south London, attended by two hundred delegates, including many of the German colleagues Marriott had met. A year later, the FIU, with Tisdall and McDowell, presented a two-day programme at the Arnolfini in Bristol, to accompany the showing there of *Bits and Pieces*. These events represented the high points of this phase of FIU activities in Britain. Marriott noted a third phase, which is still evolving, at Oxford Brookes University. This is based around the Social Sculpture Research Unit led by Shelley Sacks, who had participated in the hundred-day discussions at Documenta 6 in 1977, before returning for a while to her native South Africa. Tisdall contributes to the Sustaining Life Project as a professor of arts, music and publishing at Oxford Brookes.

The initial choice of Ireland as the headquarters of the FIU in the 1970s was

Beuys at Sandycove, where James Joyce lived before leaving Ireland for Europe.

based on its cultural and religious traditions and its recent history of sectarian violence. A further reason was its ancient tradition of scholarly learning, which predated the arrival of Christianity in this western margin of Europe, but became a central characteristic of the monastic traditions introduced by St Columba and other early Christian monks. Ireland, with its linguistic traditions and its Celtic roots had maintained an extraordinary capacity for storytelling and linguistic innovation. In his autobiographical text *Life Work/ Course Work*, Beuys recorded reading James Joyce's *Finnegan's Wake* in 1950. Eleven years later he was in a position to extend Joyce's masterpiece by adding two chapters to *Ulysses*, he related, 'at James Joyce's request'. This extension took the form of a series of drawings in a notebook. Beuys delighted in the

fact that their names rhymed, calling one of his multiples *Not by Joyce* 1984, and alluding to the earthy foods in Joyce's books by referring to 'eight mutton kidneys' in his *Art-Rite* multiple of 1981.[56] His knowledge of Joyce was profound, as Richard Hamilton discovered when he visited Beuys in London in the early 1970s, hoping to dine out with him. He found that Beuys had already bought sheep's kidneys and cooked them on a stove in his room. 'Being in London', Hamilton recounted, 'somehow reminded him that Leopold Bloom fried kidneys in "Ulysses". My comment that Bloom had eaten pig's kidneys provoked a torrent of Joycean erudition. Though Beuys's fluency in English, at that time, was not great, his knowledge of a masterpiece of English literature was intense and deep.'[57] Anne and Anthony d'Offay, mentioning Thomas Hardy, Oscar Wilde and Alfred Lord Tennyson, recalled Beuys's extensive knowledge of English literature, read both in translation and in the original English.[58] To improve his English, Beuys carried a small notebook round with him, in which he would write four or five words, that he would then try and use in subsequent conversations.[59]

Beuys investigating the plant life of Ireland, November 1974.

Language became for Beuys of ever greater importance in the spreading of his ideas. The first physical act was in the production of sound to create words then meaning, so Joyce remained a vital figure for the groundbreaking creativity in his use of language and for the complexity of his stylistic and technical approach to narrative. Beuys, like Richard Hamilton, was strongly drawn to Joyce's writing. Indeed there were plans to show in Dublin both their bodies of work connected to *Ulysses* on 7.7.77, another magical date, some fifty-five years after the first publication of *Ulysses* on 2.2.22, Joyce's fortieth birthday. Hamilton conveyed the richness of Joyce in his own work when considering the 'Oxon in the Sun' episode of *Ulysses*: 'the birth of a child in Horne's house ... is echoed in the text by the birth of language, and its historic progress, in a procession of English prose styles, from Latin incantation through Anglo-Saxon, Mandeville, *Morte d'Arthur*, Milton, Bunyan, Pepys, "and so on through Defoe-Swift, and Steele-Addison, in a frightful jumble of Pidgin English, nigger English, Cockney, Irish, Bowery slang, and broken doggerel" as Joyce himself describes it'.[60] Beuys was just as acutely attentive to Joyce's freedom with speech and linguistic invention, which provided the artist with an exemplar from another field of creative activity for his own work.[61] As Walker observed, 'it was Joyce's revolutionary and disrespectful re-invention of mythology, both Celtic and Greek, that spoke directly to Beuys. Creative subversion is the key to all art that expands perception of reality; in "Ulysses" Joyce stood Greek mythology on its head in a most irreverent, witty and moving fashion, while re-introducing its relevance to the contemporary world.'[62]

AUG. 1980 WHILST THE EDINBURGH FESTIVAL PROGRAMME INCLUDES A 3 DAY 'ACTION' BY JOSEPH BEUYS.

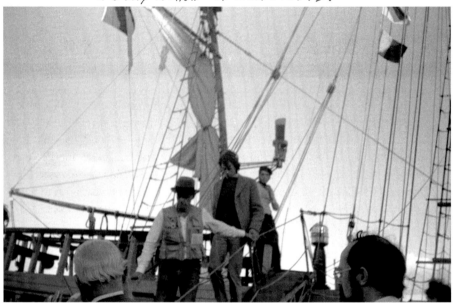

JOSEPH BEUYS DISEMBARKING FROM 'THE MARQUES'

Scotland

On the Road to Meikle Seggie was the title given by Richard Demarco to an exhibition held in Kingston upon Thames, in Surrey, in 2000. Meikle Seggie denotes an actual location for a place that no longer exists, except as a trace.[63] For Richard Demarco it has the value of a metaphor, a literal signpost to a real but also to an imagined place: Meikle Seggie is on the route from the Lowlands to the Highlands, the gateway from civilised Scotland and the touristic land of tartan and shortbread, to the authentic Scotland of Celtic mythology and the Western Isles.[64] The place, as well as the journey to it and beyond, became leitmotifs for Demarco's activities during successive Edinburgh Festivals during the 1970s. Some directly involved Beuys; his influence was in any case pervasive due to the inspiration his ideas held for Demarco. This extended far beyond the scope of exhibitions Demarco organised in Edinburgh, to the expeditions he arranged under the auspices of his Edinburgh Arts, which included, in 1975, one from Malta to the Western Isles of Scotland and, in 1980, a sea voyage around the coast of Britain in a barque that later found fame as the 'Beagle' in a television series on Charles Darwin; there is a photograph of Beuys on board before its departure.

Demarco was the first person to invite Beuys to the British Isles. With an unerring instinct for finding the person who could show him what might interest him most about a new place, Beuys found in Demarco the ideal collaborator and guide. The power of Scottish myth and legend was present from their earliest exchanges, when Demarco finally managed to meet Beuys at the artist's studio in Düsseldorf in 1970. Demarco was soon showing Beuys postcards of Scottish castles, cattle, mountains and islands. With suitable theatricality, and possibly setting the tone for Beuys's initial perceptions of Scotland as a mythic space as much as a geographical location, Demarco records him and Beuys parting with the words, 'I see the land of Macbeth.' In early May 1970 Beuys visited Scotland for the first time. Almost prophetically, given Macbeth's 'thunder, lightning, or in rain', his arrival coincided with a dramatic electrical storm. One of the many hundreds of photographs taken by Demarco, a habit pursued with dedication over his lifetime, shows Beuys in the Scottish countryside within an hour of his plane landing. Soon after, on 8 May, they visited Loch Awe and Kinloch Rannoch.

In the marginal comments to one of his photographs of that journey, Demarco described this as their 'journey to the world of the Celts'.[65] Loch Awe provided Beuys with found materials for *Loch Awe Piece* 1970, the first sculpture he made using Scottish materials.[66] It consists of a lump of peat, a small piece of bog pine, into which the artist cut a notch, and a length of copper tubing that Beuys bent into a 'Z' shape. The peat, part of the local topography and still valuable as an energy source, was a material and subject to which Beuys returned in his subsequent trips to Ireland, most specifically in the small *Irish Energies* sculptures, 1974, now in *Bits and Pieces*. These consisted of briquettes of peat compressed into geometric, including hexagonal, forms, between which Beuys smeared Kerrygold butter.[67] In Ireland, peat was still used in the domestic economy as an energy

MAY · 1970

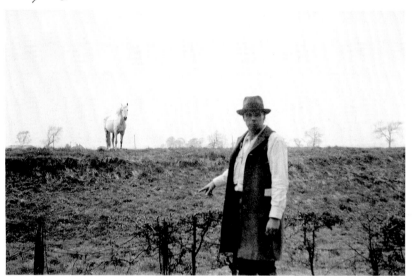

JOSEPH BEUYS WITHIN AN HOUR OF HIS ARRIVAL AT EDINBURGH'S TURNHOUSE AIRPORT ACKNOWLEDGING A WHITE HORSE

source for heating, in spite of growing pressure from environmentalists concerned about the destruction of the indigenous habitat by its systematic removal and the impact of drainage.

By bending the copper rod in *Loch Awe Piece*, Beuys transformed it into a 'Eurasian staff', an object akin to a walking stick or shepherd's staff. Beuys fashioned the staff from a material known for its properties for conducting energy and, metaphorically, ideas. The elongated 'Z' shape gave it an extension outwards along its length that forms the main stick, from the sender of these currents and missives to a possible recipient; on the curves of the 'Z' shape it bent back on itself, to conduct back the response or reaction. Beuys later put these objects in a long, narrow box made of lead, a material with properties that isolated and insulated the contents from their surroundings. Later still, for an exhibition in 1983 at the Anthony d'Offay Gallery in London, Beuys combined this open-topped box with another, a wooden crate painted grey, upon which he put a drawing and an exercise book. He placed both boxes into a vitrine to form the *Loch Awe* vitrine,

1963–70.[68] This range of responses, on the one hand to the land of Shakespeare's *Macbeth*, on the other to locally found, unassuming objects connected with a specific terrain, is wholly characteristic of Beuys's practice of intuiting his way towards the essence of a place in all its dimensions.

Rannoch Moor is one of the wilder, more ancient landscapes in Scotland, later described by Beuys as 'the last European wilderness'.[69] The deglaciation of the upland plateau has left a desolate stretch of peat and bog, strewn with rocks and accessible from east to west only on foot. Here, according to legend, was the last sighting of wolves in Scotland. Rannoch Moor is the watershed in the central region of Scotland from which rivers flow either to the Atlantic in the west, or to the North Sea in the east. Kinloch Rannoch is a small village at the eastern end of

MAY 1970

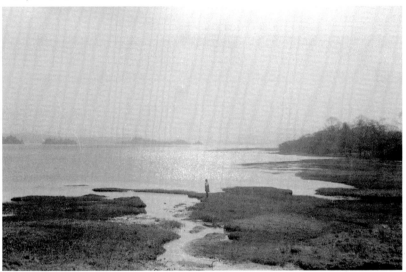

JOSEPH BEUYS AT THE WATER'S EDGE OF LOCH AWE – LOOKING FOR DRIFTWOOD & PEAT

Loch Rannoch. When asked by Demarco in 1970 to contribute to his proposed summer exhibition of German artists from Düsseldorf in Edinburgh, Beuys had requested Demarco provide certain things. These included a grand piano, an axe, gelatine – for the first time – and film.[70] His visit in early May 1970 to Rannoch Moor inspired a film, which was projected during the action at Demarco's exhibition at the Edinburgh School of Art three months later. Filmed by Mark Littlewood with assistance from Rory McEwen, the *Moorfilm* showed a slow progress through the landscape of Rannoch Moor, interrupted by the intermittent sight in the foreground of the artist's hand, shaping then throwing into the air a small lump of fat. According to Beuys's recollection, this was sometimes a lump of gelatine. For the artist this lump was a small piece of indigenous material that epitomised the desolate moorland, similar in function to the piece of peat found for *Loch Awe Piece*. Demarco interpreted the small lump – of butter, he claimed, not fat – as a 'drawing material'. Beuys used it, Demarco wrote, for exploring 'the energy inherent in the rain-soaked moorland which lies just south

of the Kingshouse Hotel, in the road from Bridge of Orchy to the mountains of Glencoe that day obscured in mist and rainfilled clouds'.[71]

Beuys's mention of small lumps of gelatine, whether or not erroneously, in his recollection of making the film, possibly accounts for the enigmatic presence of pieces of gelatine on the walls of the room in which he performed his *Celtic (Kinloch Rannoch) Scottish Symphony* action when he returned to Edinburgh later that year. This was the first time this particular material had appeared in an action, although he had, in 1963, made a small untitled sculpture consisting of gelatine blocks to which was attached a transformer sending a weak electrical current.[72] His student Johannes Stüttgen helped Beuys to apply the pieces of gelatine to the walls of the Edinburgh College of Art before each of the twelve performances of

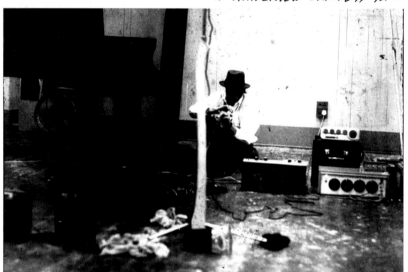

Celtic … at the end of August 1970.[73] Perhaps Beuys meant the lumps of gelatine he used in the *Celtic* … action to be understood as material analogues for the deglaciated, boggy, rock-strewn landscape depicted in the *Moorfilm*, which was projected directly on to the wall in the room as part of the *Celtic* … action. The pieces of gelatine were on the wall on to which Beuys's film was projected, before he slowly removed them and put them on a plate during one sequence of the action. Their initial presence, then disappearance, from the walls suggests a gradual transformation in the landscape of the film. This interpretation, with which Stüttgen concurs, is strengthened by the activity Beuys undertook on 13 August 1970, when he returned to Rannoch Moor and deposited small lumps of gelatine and margarine in the landscape. Susan and Alexander Maris, Scottish artists who have recently retraced Beuys's steps during that summer, suggest this was a remedial act in response to the de- and reforestation of Loch Awe side that Beuys encountered on his visit with Demarco. 'Perhaps,' they write, 'his gift of a

1970 · EDINBURGH FESTIVAL
THE DRAWING ON THE BLACKBOARD RELATES TO 'SOUND' OF

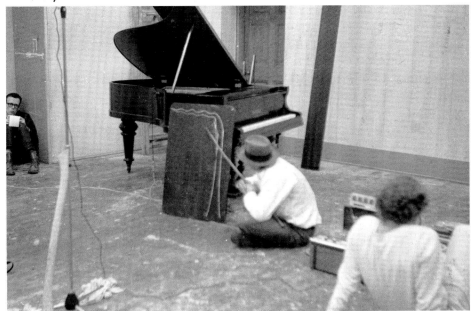

↑ JOHANNES STÜTGEN ↑ JOSEPH BEUYS HENNING CHRISTIANSON
 ↗

AUG 1970. CELTIC KINLOCH RANNOCH TWO PORTABLE AXE MICROPHONE
 —ACTION BY JOSEPH BEUYS TAPE RECORDERS ↘ ↓

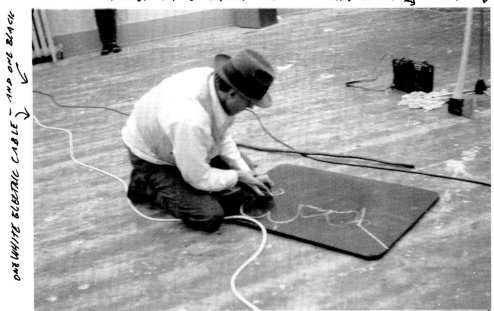

JOSEPH BEUYS DRAWING WITH WHITE CHALK UPON THE
MOVABLE BLACKBORD; EACH DRAWING TRANSIENT

1970 · EDINBURGH FESTIVM

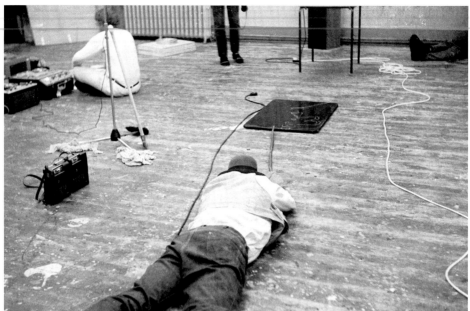

HENNING CHRISTIANSEN ADJUSTING THE SOUND ON ONE
TAPE RECORDER AS JOSEPH BEUYS PUSHES THE BLACKBORD

AUG. 1970 — AT EDINBURGH COLLEGE OF ART.

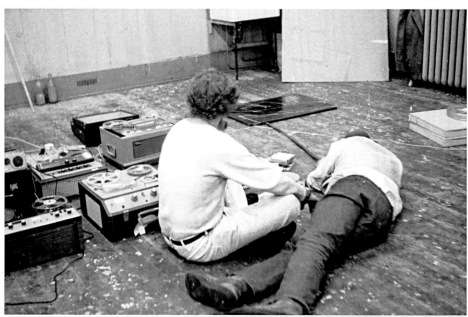

HENNING CHRISTIANSON & JOSEPH BEUYS — CONTRIBUTE
TO THE EXHIBITION " STRATEGY · GET — ARTS "

1970 — THE FLOOR OF THE LIFE ROOM AT EDINBURGH COLLEGE
OF ART WAS BESPATTERED WITH THE OIL PAINT OF

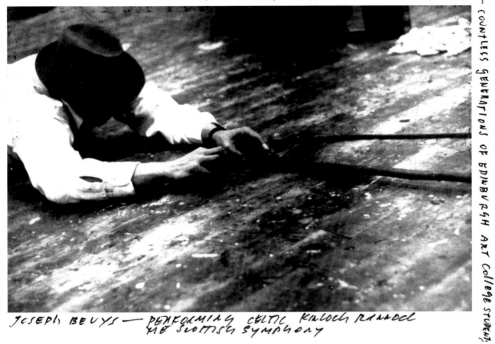

COUNTLESS GENERATIONS OF EDINBURGH ART COLLEGE STUDENTS

JOSEPH BEUYS — PERFORMING CELTIC KINLOCH RANNOCH
THE SCOTTISH SYMPHONY

1970 · JOHANNES STUTTGEN, AS ONE OF BEUYS' STUDENTS
PLACED 3 SMALL SHEETS OF PAPER WITH NAMES OF ARTISTS

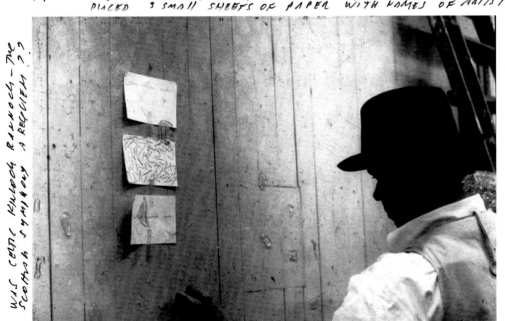

WAS CELTIC KINLOCH RANNOCH — THE
SCOTTISH SYMPHONY A REQUIEM ??

AND WHERE ARE THE SOULS OF WILLIAM BLAKE, FRA ANGELICO
REMBRANDT, VAN GOGH ETC. ETC —— AND LEONARDO DAVINCI ?

gelatine heart to a long-destroyed forest can be indirectly related – like the parentheses around (Kinloch Rannoch) – to a forest of new oaks.'[74]

Rannoch Moor and the village of Kinloch Rannoch gave Beuys's action its roots in a specific location. The way in which geography blurs into mythology, however, is indicated by Demarco's description of that ancient landscape as the 'world of the Celts'. The idea of a Celtic culture, its spirituality anchored within the natural world, was a central element in the ritual enacted by Beuys at the Edinburgh School of Art. Beuys's empathy with Celtic culture evolved from many sources. Its roots, perhaps, lay in his perception of his own origins in the Celtic enclave of Cleves. Tisdall describes the meeting of history, religion and race in Beuys's home town, which she refers to as 'a Celtic and Catholic enclave in a Germanic and Protestant country, a place where the border counts for little in the

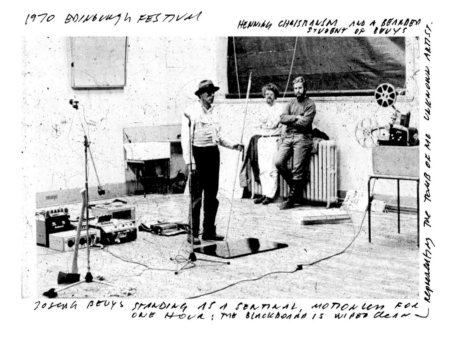

1970 EDINBURGH FESTIVAL

HENNING CHRISTIANSM AND A BEARDED STUDENT OF BEUYS

(REPRESENTING THE TOMB OF ME UNKNOWN ARTIST)

JOSEPH BEUYS STANDING AS A SENTINAL, MOTIONLESS FOR ONE HOUR; THE BLACKBOARD IS WIPED CLEAN

minds of the people; by name and culture many are Dutch, just as the land has been at times in the past. The history of Europe has been played out over this land, by Romans, Batavians, Franks, Germans, Frenchmen and Spaniards.'[75] Stüttgen recollected Beuys's knowledge, filtered in part through his reading of Rudolf Steiner, of the *Hibernian Mysteries*. These recounted spirituality in Britain and Ireland before the arrival of the Romans, in which mystical experiences occurred as direct revelations and the spirituality of humans was rooted in the experience of the natural world.[76]

Modern Celts, according to Liam de Paor writing in the 1970s, consist of communities in Brittany, Wales and isolated pockets along the coasts of Ireland and Scotland.[77] Originally Indo-Europeans, the prehistory Celts, de Paor continues, 'remained on the margins of the expanding world of Mediterranean urban civilisation'.[78] Although ultimately absorbed by the Roman Empire, the Celts, following their conversion to Christianity, retained their institutions and

kept their myths and perceptions about humanity's place in the natural world as an integral part of their world view. These qualities harmonise with another of Beuys's interests, particularly during this phase in his career, that of peripheral cultures in Europe. Indeed, far from being marginal issues, or merely historical phenomena, questions about the survival of certain minority cultures at the margins of Europe appeared increasingly topical. Some of these debates, indeed, were amplified because they appeared threatened by the trend of European integration. This was gaining in pace through the expansion of the European Economic Community, which Britain, Ireland and Denmark joined in 1973. The pull towards a greater European entity had the effect that the Celtic parts of Britain and Ireland, particularly Cornwall with its strong regional identity, and parts of Wales and Scotland, all began to re-examine their cultural and national identities.

MAY ~ 1970

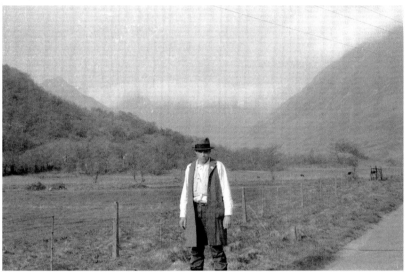

JOSEPH BEUYS IN THE WORLD OF THE CELTS BEYOND GLEUCOE

The intensity of Beuys's motionless, staff-wielding stance facing his audience at the end of the *Celtic ...* action, and the frequency of his return visits to Scotland during the 1970s, suggest an engagement with Celtic myth and culture beyond the merely superficial. He found in Demarco and Tisdall friends and collaborators who hailed each other on occasion as 'fellow Celts'. Indeed, Beuys's identification with their common Celtic heritage led him to inscribe a photograph of his 1971 *Bog* action (in Holland) 'the other part of the irish running to you' when he gave it to Tisdall as part of *Bits and Pieces*.[79] Beuys's fabrication of a Eurasian Staff for *Loch Awe Piece* suggests, further, his recognition of the particular role Celtic culture and religion played in European history over the past several thousand years. In prehistory, Celtic peoples travelled westwards, and thus migrated from the eastern to the western reaches of the terrain Beuys described as 'Eurasia'. Robert O'Driscoll, the driving force behind the major Celtic Consciousness Conference in Toronto in 1978, reflected upon the east–west expansion by the

Celts in history. Using the image of the cauldron, a recurring motif in Celtic mythology, he wrote:

> *on a more literal level, the cauldron seems an appropriate image to represent the fate of the Celts in the Western world. They seem to have emerged from the east; then, for almost a thousand years, they dominated the centre of Europe, stretching from the Black Sea to Iberia and from the Mediterranean to the North Sea and Ireland. Two thousand years later they survive on the western periphery of Europe, having been pushed to the extreme edge of the cauldron.*[80]

This idea of survival, against the odds, in adverse weather conditions, when technology collapses, when simple direct solutions are called for, is intrinsic to *The Pack*, which Beuys elected to present in the *Strategy: Get Arts* exhibition in 1969. The context for exhibiting it in Edinburgh might be interpreted, in addition, as an analogy for the survival of Celtic culture.

Perhaps, also, Beuys intuitively recognised the purity of the Celtic, or British, Church during the first five hundred years after Christ, when Celtic spirituality was assimilated into Christianity. Christopher Bamford asserts that the simplicity and asceticism of Celtic spirituality, perhaps matched only by the traditions of the East, created, as an alternative to those Eastern traditions, 'a light from the west'.[81] The absorption of the British Church by the spread of Roman Catholicism after the fifth century AD meant an alternative path of purity and simplicity was lost to Western man. Writing in 1943 about the passing of the British Church, H. J. Massingham argued, 'it is possible that the fissure between Christianity and nature, widening through the centuries, would not have cracked the unity of western man's attitude to the universe'.[82] The early British Church

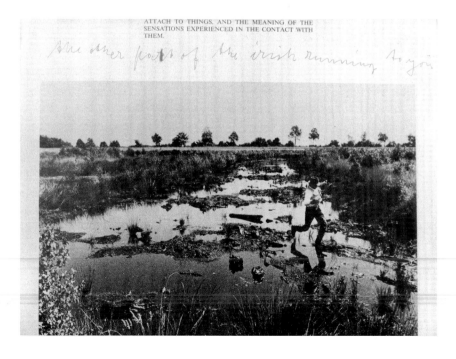

'The other part of the irish running to you' inscribed by Beuys on a photograph he gave to Caroline Tisdall

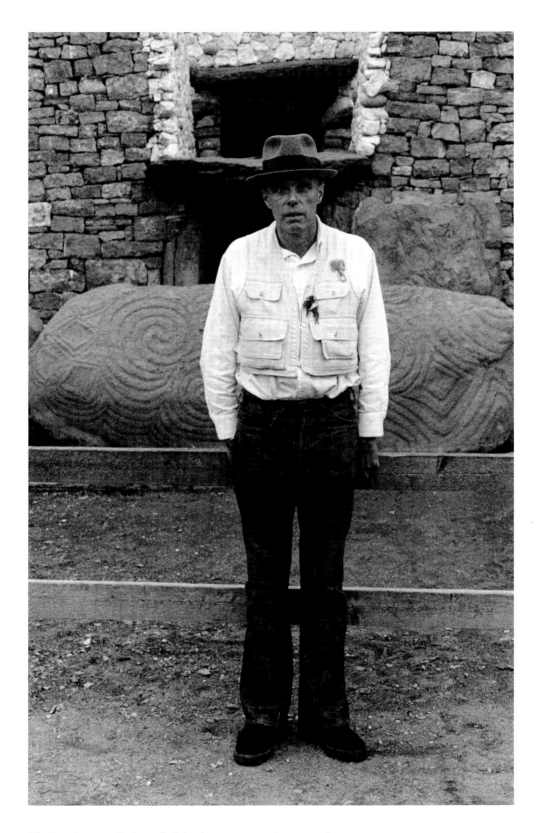

The Great Stone outside the Tomb of the Kings, Newgrange, County Meath.

combined saintliness with ecology and, according to Bamford, created a heritage that linked the sacred and secular. Branches of 'learning, science, poetry and art … were seen as the essential concomitants, the frame and the vehicle, whereby God's purpose for the cosmos, its transfiguration, might be aided and fulfilled'.[83] During this early period, the role of priest was combined with that of poet and visionary. Druids, holy men of the period, were acknowledged for their knowledge of the natural world; these were men of special gifts – the bards, druids and doctors – who were the equals of the chieftains and tribal leaders. In Ireland, the druids, once converted to Catholicism, learned Latin and so 'incorporated their own traditions into the existing Christian ones'.[84] With Celtic Ireland having always cultivated a 'lore of places', according to Bamford, 'we will find [there] a holy intimacy of human, natural and divine. In hermitages and monasteries, on rocky promontories and lonely hillsides, we find everywhere a tremendous proximity of the human and divine in nature, an abandonment to spiritual work and simultaneously a cultivation of the earth.'[85] Oaks, which occur consistently in Beuys's art, were integral to Celtic culture, as the druids' sacred tree. As an indigenous tree, Walker observed, it is evident in many place names, 'which include the word 'Derry' from the Irish 'doire', an oak-wood'.[86] In *Ireland* 1950, a drawing in *Secret Block for a Secret Person in Ireland*, a Celtic cross is embedded within what might be interpreted as a hilly terrain.[87] Beuys's creation of *Loch Awe Piece* might also be viewed in the light of such an intuitive closeness with the earth, if not its cultivation, while his presentation of the self in *Celtic …* appeared to return him to being in tune with the spirit of both heaven and earth. Demarco instinctively recognised this quality in Beuys's work. Writing to Tony Firth, then Controller of Programmes for Scottish Television (to interest him in helping to make, then screen, *Moorfilm*), Demarco enclosed a recent article on Beuys, with the comment: 'This will give you an idea of Beuys' genius and how the whole "earth" and "land" environments are growing out of Beuys' philosophy.'[88] The Rannoch Moor film had an afterlife following its inclusion in the *Celtic …* action. In October and November, after the end of *Strategy: Get Arts*, Demarco encouraged Beuys to release the film as an editioned multiple. Indeed a London dealer, Anthony de Kerdrel, offered to buy all twenty of the proposed edition. It was never published as a multiple, although the film of the action in Basel, *Celtic +* ‿‿‿ , was in 1971.

Beuys's ready assimilation of the romance of the Scottish wilderness, as well as its legends, was demonstrated not only by the 'Macbeth' farewell he and Demarco exchanged before he travelled to Scotland for the first time, but also in comments he made to Hagen Lieberknecht shortly after that first visit to Edinburgh. The importance of the *Celtic …* action, which encapsulated aspects of the artist's own life and aspirations, was confirmed by Beuys's comment: 'it had dwelt within me for a long time already: Scotland, Arthur and the Knights of the Round Table, the Legend of the Grail. The elements all came together … One cannot view [the action] simply as a composed score. The preparatory work is connected to my life.'[89] Indeed, as Beuys remarked to Demarco, this was not actually his first visit to Scotland; he had touched down for forty minutes at Prestwick airport near Glasgow en route to Halifax, Nova Scotia. Having visited the Nova Scotia College

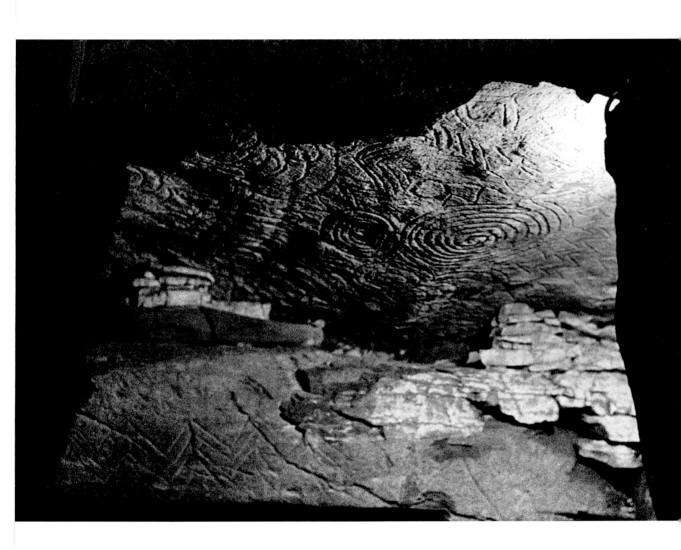

The Tomb of the Kings at Newgrange, County Meath.

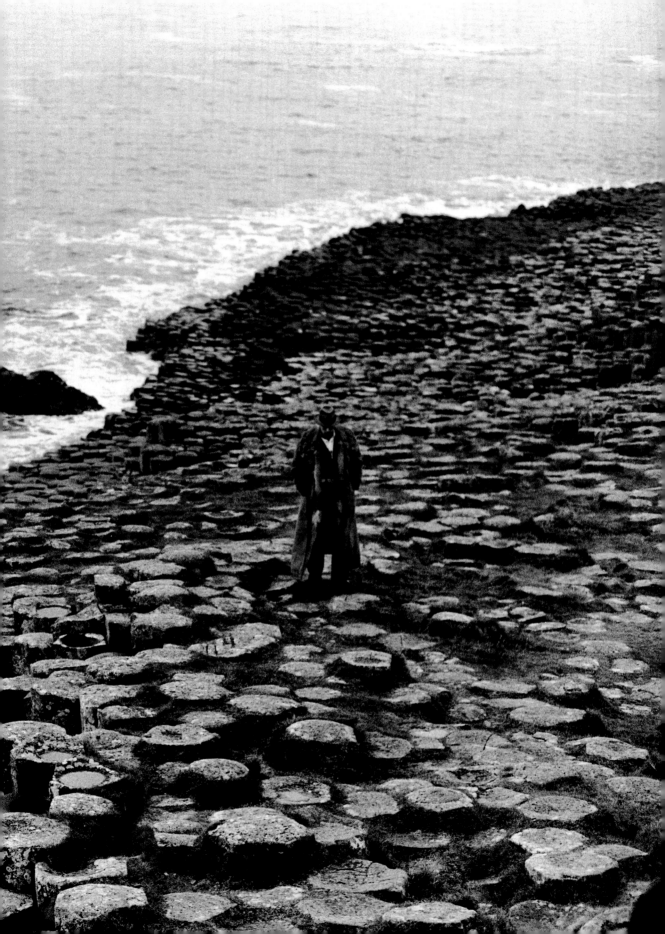

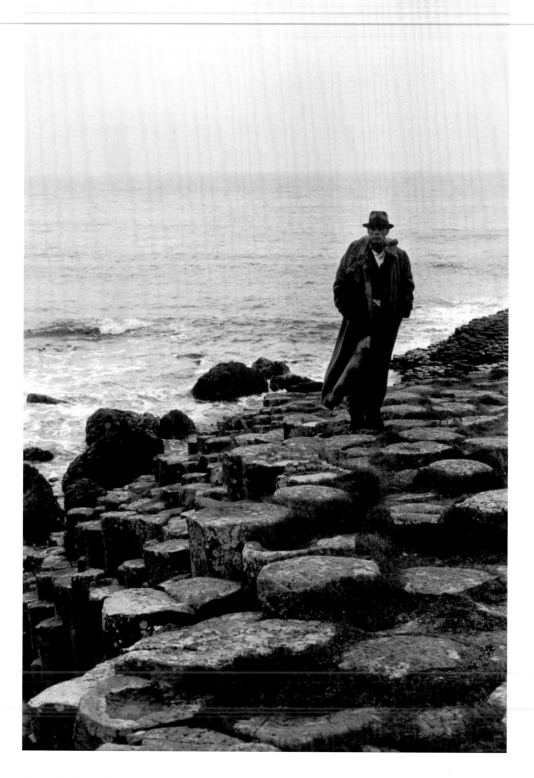

60 *Beuys at the Giant's Causeway.*

of basalt stelae in front of the Museum Fridericianum Kassel, with a single oak planted at the sharp end of the pile. Over the following decade each basalt column was sponsored for removal and 'replanting' somewhere else in the city, alongside a newly planted oak tree. This became Beuys's most expansive, time-based project – a social sculpture – motivating citizens to become involved in a process of urban change and renewal that would mature, with the trees fully grown, only decades after their deaths. This cycle of life and death, holding the potential for renewal at its core, is at the heart, also, of *The End of the Twentieth Century* 1983–5. A large sculpture comprising basalt blocks each with a cone of stone cut out and then reset, Beuys made four versions of the work at the end of his life, specifically for a museum, as opposed to an urban, public environment.

The welcome Beuys received in Scotland was heavily dependent on the enthusiasm and energy of Richard Demarco, but also on the cultural dynamism that emerged in the Scottish capital in August every year during the Edinburgh Festival. Before the 1970s the contemporary visual arts played a relatively minor role in the Festival. However, this changed when Demarco was asked to organise an exhibition in 1970. Demarco had run his first gallery in the city in 1966. When Beuys arrived in Scotland for his first trip, between 6 and 8 May 1970, he, Demarco and the German critic Georg Jappe toured Edinburgh, including Arthur's Seat (which Beuys initially considered as a possible site for his *Celtic …* action),[96] before Beuys travelled on to the Highlands with Demarco and one of his assistants, Sally Holman. Demarco recalls the family atmosphere of his gallery during those years, one particularly appreciated by Beuys who, according to Demarco, was the only artist whose own family attended the opening of the *Strategy: Get Arts* exhibition later that summer.[97] Holman's parents, James Holman and the actress Linden Travers, had opened the Travers Art Gallery in Kensington, London, in 1969. While in Scotland to see a rugby match at Murrayfield, they contacted Demarco. His gallery was then called, coincidentally, the Traverse Gallery, through its link to the famous Traverse Theatre. Both galleries were showing St Ives artists at the time, which provided the specific connection. A few years later, collaborators whom Demarco viewed as his 'family', including Holman, Sandy Nairne (then a student, and the Director of the National Portrait Gallery in London) and, later, Mark Francis, were active in Oxford, thus offering him opportunities for touring his exhibitions.

Demarco's broad-based Edinburgh Festival programme included artists from Eastern Europe and the Balkans. He created particularly fruitful collaborations with the Polish artist and theatre director Tadeusz Kantor, who brought two productions to the Festival in 1972 and 1973. According to Demarco, through this link Beuys established contact with others involved with avant-garde art in Poland, such as Ryszard Stanislawski of the Museum Sztuki in Lódź. This connection with Poland, via Edinburgh, contributed to Beuys's decision in 1981 to deliver to Lódź, as a gift, a large group of his works, mainly multiples, which he called his *Polentransport*. His gift, a gesture to heal a historic rift, recognised the importance of artists and curators pursuing their creative independence even under oppressive political systems. Moreover, its title should be interpreted as a clear reference to, and public acknowledgement of, the appalling realities of the early 1940s, during

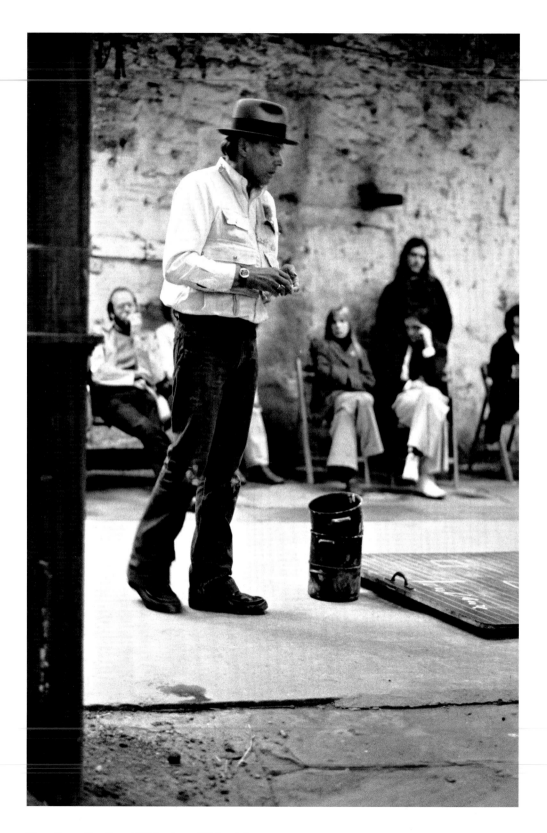

Three Pots *action, Forrest Hill Poorhouse, Edinburgh, June 1974.*

which Jews were transported to Poland to the labour and concentration camps. In *Lovelies and Dowdies*, one of Kantor's plays presented in Edinburgh in 1973, luminaries including Tina Brown and Sean Connery were persuaded to play bit parts. According to Demarco, Beuys also joined in, as one of the inmates of a concentration camp reliving the occupation of Cracow by the Germans.[98] Sandy Nairne recalled first meeting Demarco in Edinburgh in 1972 while Nairne was performing in a mystery play. Invited back the following summer to help with the summer school Demarco established, Nairne was thrown in at the deep end and made production manager for the Kantor performance. Memories of the *Strategy: Get Art* exhibition were still very strong, especially in the Demarco circle. Nairne's first impression of Beuys, during August 1973 in Edinburgh, where he gave an

AUG. 74 - LEAVING THE POORHOUSE ON FORREST HILL THROUGH THE SMALL DOOR, JOSEPH BEUYS IS THINKING OF SCOTTISH OIL.

THE POORHOUSE DOORS COVERED IN POSTERS LINKING THE WORLDS OF TADEUSZ KANTOR & JOSEPH BEUYS AT THE 1973 EDINBURGH FESTIVAL

extended reading of the writings of Anarchasis Cloots, was of someone exuding immense calm. His evident spirituality and the sense he gave of being rooted in the earth shone alongside the more transitory shifts of everyday human emotions. Three years earlier, when returning to Demarco a book about Beuys, the artist David Tremlett also commented on Beuys's spiritual aura: 'I envy the solid state of his religion, of his work, it is something that has taken a long time.'[99]

The spirit of Kantor, who presented plays in Edinburgh in 1972, 1973 and 1976, pervaded the Poorhouse at Forrest Hill, the venue Demarco found to stage his productions. One of several former poorhouses in the city, it was the antithesis of a customary theatre or gallery space, with its rough walls and dilapidated state. In early June 1974, the year after Kantor's last production, and in anticipation of a conference on oil to be held in Edinburgh that August, Beuys performed his *Three Pots* action at the Forrest Hill Poorhouse, which Demarco described as an act of communion 'with all the untold generations who had known the Poorhouse as a place of suffering and impoverishment'.[100] Beuys's action was extremely simple:

he walked slowly round the room with a pot in his left hand, touching with his other hand the surfaces of the walls with all their bumps and unevenness. He then repeated his tour of the room with a second pot balanced on the first; then again with a third pot balanced atop the first two. After that he placed them in the centre of the room near two blackboards, on which he wrote extracts from his talk. The three pots, he said, represented the elements of 'thinking, feeling and will', which needed to be held in equilibrium; kept upright, the pots would not topple and nothing would spill from them. In his lecture, reflected in the words on the blackboard, '3 total economic Model, 2 dualistic, 1 cultural', Beuys expanded the tripartite concept of 'thinking, feeling and will' in a discussion about freedom, democracy and socialism. These ideas were closely related to Rudolf Steiner's thinking about a human society built upon three principles, 'socialism in economic life, democracy before the law and state, and the freedom of the individual in matters of the spirit'.[101] Unusually for the fate of his works entering public collections in Britain, the two blackboards, to which the three pots were attached by cord, were acquired soon afterwards by the Scottish National Gallery of Modern Art. The special association Demarco, Kantor and now Beuys had with the Forrest Hill Poorhouse led Beuys to make a sculpture commemorating his activities there when it was sold to developers in 1981. Demarco showed Beuys photographs of the doors and, noticing the remnants of posters from earlier events, his own and Kantor's, Beuys detached the massive doors at the entrance to the poorhouse and created *Poor House Door – A New Beginning is in the Offing* 1981, now in the collection of the Museum Abteiberg in Mönchengladbach.

Aside from Kantor and Beuys, the third important figure in Demarco's Festival programmes as they developed through the 1970s was Paul Neagu.[102] Neagu was of primary importance to Demarco, who valued the artist's annual visits to his Edinburgh Arts summer school between 1972 and 1980. Demarco suggested that Neagu's presence, an outsider figure who sought asylum in Britain after leaving

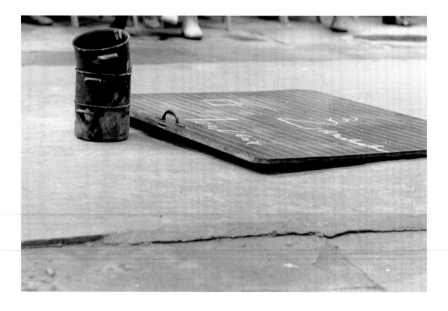

Three Pots *action, Forrest Hill Poorhouse, Edinburgh, June 1974.*

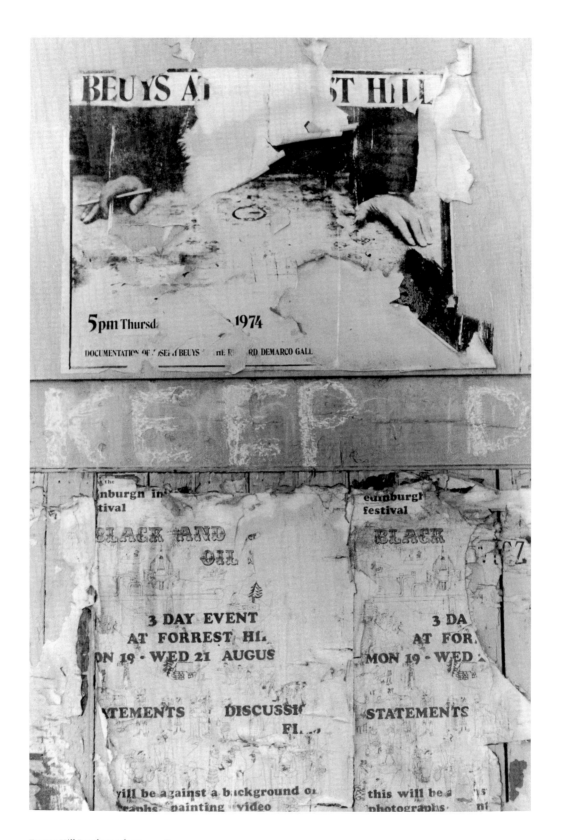

Forrest Hill Poorhouse doors, c.1980.

his native Romania, strengthened Beuys's own commitment to Scotland, particularly during the period following Beuys's dismissal from the Düsseldorf Academy of Art in 1972. Scotland, as Neagu later reminded Demarco, had had a transformative effect on his art:

> when in 1968 we met in Bucharest ... my work, research and visual inquiries were full of cells, boxes upon boxes ... Even since 1969–72, particularly when coming to Scotland, Callanish, Outer Hebrides, Brochs, Standing Temples of Stone, Celtic Works of Intricate Curves, my obsession with cells within cells has reworked itself around a centre. First of all this centre was my soul – an historic ritual around a spiral, around a centre.[103]

One of Neagu's most important actions, *Going Tornado* 1974, was filmed by Grampian Television. The power of the vortex, attained through the spinning, spiralling movement in the action alluded to spiritual rituals and the power of revelation, achieved through intense, creative activity.[104]

The spiral, a Celtic symbol of energy, became for Beuys, too, an important motif. He encountered it, most potently, in the carved stones inside and outside the tomb of the kings at Newgrange, Meath, in eastern Ireland, which he visited in 1974. According to Caroline Tisdall, these inscriptions indicated a sophisticated knowledge about energy among the ancient Celts who carved them: 'The three energies are the spiral, organic or implosive form, the split cell and the diamond-shaped crystalline or explosive form. Beuys interpreted this as an early example of the principles to which he referred in his Theory of Sculpture: the passage from warm, organic form (e.g. liquid fat) to cold, crystalline form (e.g. solid, sculpted fat).'[105] Beuys depicted all three forms of energy, the implosive spiral, the explosive cystal and the split cell, in a small sketch, now part of *Bits and Pieces*.[106] Some of these motifs, in particular the spiral, are picked up in *Cairn III* and *Cairn IV*, both 1974, in *Secret Block for a Secret Person in Ireland*.[107] The characteristic triple spiral motif of the stone at Newgrange, along with another twin spiral, is superimposed on a list of dates and work titles in another drawing, titled *Newgrange* 1970, after the Irish site.[108] Its visual impact was also translated into one of the blackboard drawings Beuys made when he returned to London from this visit during the twenty-four-day run of *Art into Society – Society into Art* at the ICA, where he was in the process of making what became *Directional Forces* 1974–7.[109]

Neagu's work in the 1960s and 1970s, like that of Beuys, reflected the status of sculpture as the most avant-garde of art forms. Through performance and film he explored the relationship between art and society. One of his students, the sculptor Anish Kapoor, wrote about Neagu's uneasy acceptance by the British art world of the time: 'Inevitably, he struggled against a British art world that preferred to see the artist as a maker of things rather than, as he saw it, art, and therefore the artists, as a generator of a philosophical world view.'[110] These words could equally well have been written about Beuys. Neagu's complex view of the world found an outlet in the form of fictive collaborators, each of whom reflected different facets of his creative mind. These became members of what he termed the Generative Art Group. For a short time in the mid-1970s Neagu ran

1975 —— EDINBURGH ARTS.

PAUL NEAGU IS A ROMANIAN ARTIST WHO FIRST EXHIBITED IN THE DEMARCO GALLERY IN 1968

CALLANISH IS A MEGALITHIC LUNAR AND SOLAR OBSERVATORY —— AND A LARGE-SCALE SCULPTURE

PAUL NEAGU AT CALLANISH
—— ON THE HEBRIDEAN ISLAND OF LEWIS

67

the Generative Art Gallery in London where, in 1976, Beuys first showed *Bits and Pieces*, the collection of drawings, objects and, later, multiples, he was gradually assembling for Caroline Tisdall. Aside from this actual accommodation in his gallery by Neagu of works by Beuys, Kapoor identified an affinity between these two artists and Yves Klein. Neagu evolved, wrote Kapoor, 'a complete anthropocosmic view which, in parallel with Joseph Beuys in Germany and, previously, Yves Klein in France, suggested a spiritual remedy for the ills of contemporary man'.[111]

One of those contemporary ills addressed by Demarco and picked up by Beuys was the Scottish prison service and its treatment of Jimmy Boyle. Boyle, a criminal then serving a life sentence for a notorious murder, was moved in 1973 from the

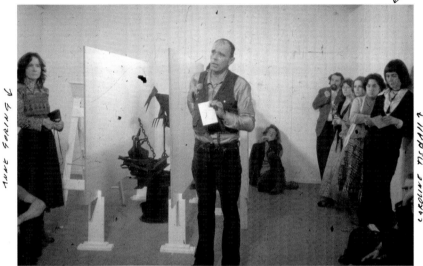

JAN. 76 / ME DEMARCO GALLERY IN MOUTRITH HOUSE HELENE VERIN

ANNE SORING

CAROLINE TISDALL

JOSEPH BEUYS "STANDING IN " FOR JIMMY BOYLE

normal, brutal regime then common in Scottish prisons to a Special Unit at Barlinnie Prison. This was an enlightened experiment in rehabilitation through the introduction of programmes of education and creativity. Boyle was inspired by Beuys's *Coyote* action (1974) at the René Block Gallery in New York, which he had seen, on day release, when it was shown as a photo-documentation at the Forrest Hill Poorhouse in Edinburgh later that summer. Boyle believed himself, a hated outcast, to be the equivalent in human society of the despised coyote, and identified strongly with the animal. Boyle's sculptures were included in *Paintings and Sculptures by Inmates of HM Prisons in Scotland*, one of the twelve exhibitions Demarco organised for the 1974 Festival. Writing shortly afterwards, in December of that year, Boyle acknowledged the importance to him of Beuys:

> At the moment I hear much talk of taking art to the whole of society, but I also experience tremendous confusion by artists on how to do this. The only worthwhile statement that has had any effect on me and others of my environment has been Joseph Beuys' dialogue with a Coyote. The others pass over the head of society and loose [sic] their impact.[112]

A year later, in December 1975, Demarco invited Beuys, in the absence of the prisoner/artist, to the opening of a show on Boyle he intended to have in January the following year. He asked of Beuys, 'maybe you could make some kind of statement or action about YOU BEING THERE representing Jimmy Boyle'.[113] Beuys visited Boyle in prison in 1976 and on subsequent occasions. When in 1980 the Special Unit was closed and Boyle was sent back to a normal prison regime in Saughton Prison Beuys protested by going on hunger strike, with Beuys's secretary Heiner Bastian and Robert McDowell. These three, plus Ian Gordon, co-signed a press statement released on 5 September 1980 by Richard Demarco urging the Scottish Office to revise the decision to send Boyle back to a closed prison, ironically at the same time as Boyle was told his provisional release date would be November 1982.[114]

Beuys empathised strongly with Boyle's predicament. His response to Boyle's portrait bust of him wearing his felt hat, surmounting the head of a coyote, was to address the physical confinement of Boyle's 'encagement' in two drawings of 1975 in *Bits and Pieces*. In one, Beuys used official prison notepaper upon which he affixed a severe, hatless passport photograph, to cast himself as the prisoner for whom freedom could only be in the mind. The caged physical body is the centre point of a second drawing. In his *Freedom for Jimmy Boyle*, also of 1975, Beuys sketched one of Boyle's sculptures as it appeared in the exhibition, surrounded by concentric rings. The central ring he labelled 'physical body'; the outer ones were called bodies of 'perception', 'feeling', 'thinking' and 'consciousness'. Tisdall proposed that Beuys was acknowledging a spiritual dimension in human life: 'prison cannot imprison the body of perception, of feeling, of thinking or of consciousness in the way it holds the physical body'.[115] In 1980, even while Boyle was still in prison, Beuys wrote to Demarco welcoming his suggestion of establishing a branch of the Free International University in Edinburgh in association with the Demarco Gallery. Describing in detail how it might be staffed and financed, he proposed, 'it would please me to know that Jimmy Boyle would be the Director of this office', continuing that he hoped Boyle might undertake those responsibilities for at least six months.[116]

Demarco's model for bringing to Edinburgh those he viewed as the most important contemporary artists working at the time came not from his experience in Europe, but from contacts made in Canada and America on his frequent lecture trips and exhibition research during the late 1960s. At the Nova Scotia College of Art and Design, Demarco was inspired by the leadership of Garry Kennedy and Gerald Ferguson. Kennedy, who was appointed President at the NSCAD in 1967, set about building the profile and prestige of the college through his philosophy of 'bringing people together and creating possibilties'.[117] Many significant artists were invited to stay and teach at the college, including Beuys who, on his second visit in 1976, was awarded an honorary doctorate, and on that occasion created a blackboard. Kennedy's success at attracting major figures to a geographically remote place inspired Demarco's efforts to attract similar figures to a city on the north-western rim of Europe without a strong history of commitment to contemporary visual art. Beuys returned to Edinburgh, not least because of his

AT THE 1980 EDINBURGH FESTIVAL

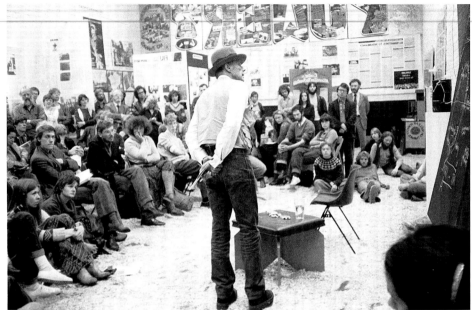

AT THE CANONGATE DEMARCO GALLERY CONSIDERING
THE "JIMMY BOYLE DAYS" BLACKBOARDS.

AT THE 1980 EDINBURGH FESTIVAL — AT THE DEMARCO GALLERY
IN THE CANONGATE

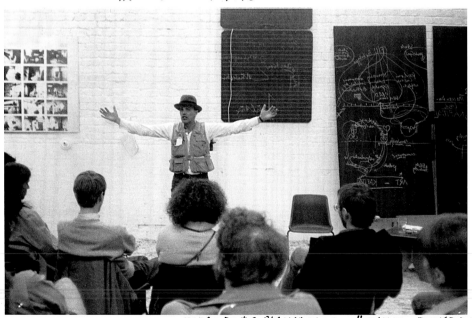

THREE POTS BLACKBOARD "JIMMY BOYLE DAYS"
BLACKBOARDS

1980 EDINBURGH FESTIVAL

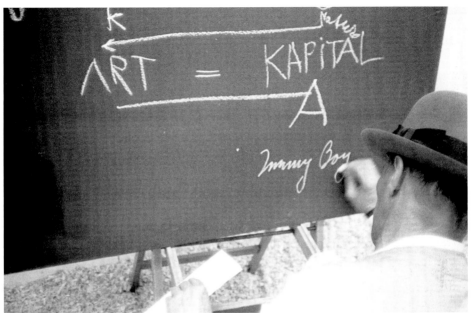

WRITING JIMMY BOYLE'S NAME

AT THE OPENING OF THE EXHIBITION OF THE MUNCHEN —
GLADBACH MUSEUM COLLECTION

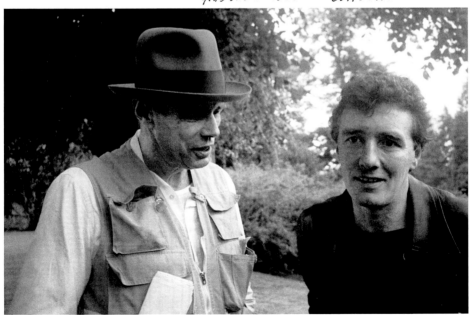

JOSEPH BEUYS AND JIMMY BOYLE
EDINBURGH FESTIVAL — 1982. IN THE ROYAL BOTANIC GARDEN

identification both with its peripheral position but also because of the personalities attracted there each August, the month most of his visits fell. Where else might he have occasion to be introduced to stellar performers in other fields, such as the time Joan Bakewell recalled introducing him to the conductor Carlo Maria Giulini at a reception in Inverleith House.[118]

Another such encounter was in 1974 when Beuys shared a platform with Buckminster Fuller, among other speakers, at the Black and White Oil Conference on the nascent oil industry in Scotland, organised by Demarco under the auspices of the Edinburgh Festival. Demarco's inclusion at successive Festivals of topics that strayed well beyond the traditional field of the visual arts was to have consequences in 1980, when his funding of the Festival was withdrawn because of the

FORRESTHILL — THE LANE, LEADING TO THE POORHOUSE

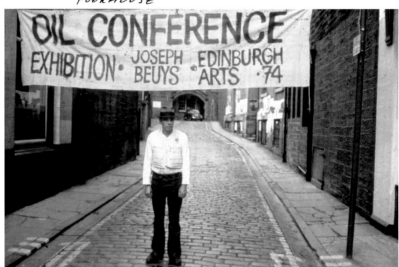
JOSEPH BEUYS PRIOR TO HIS 3-HOUR LECTURE FOLLOWING THE 3-HOUR LECTURE BY BUCKMINSTER FULLER

programme organised by the Free International University, and for Demarco's support of Jimmy Boyle. Demarco's plans for his contributions to that year's Festival spanned several exhibitions. One was on the prison system, focusing on Jimmy Boyle and the Special Unit at Barlinnie Prison. Another was to examine the political imagery of Northern Ireland. Seeds of the conflict between Demarco and Festival organisers were present from the outset, when Demarco had perennial difficulties securing funding in Scotland for his projects, beginning with *Strategy: Get Arts* in 1970. This pattern continued right through the decade.[119] Part of this, seen from the opposing viewpoint, lay in Demarco's desire to cast the net widely, bringing to Edinburgh artists from Eastern Europe whose work had never before been seen in Britain, but also in his viewing art primarily as a platform for discussion about the social, political and economic issues of the day. *Avant Garde Art: What's Going Up in the 80s*, Demarco's catalogue for the 1980 Edinburgh Festival, appeared to view art entirely as part of a broader social and political process: George Fraser asked, in his foreword to the catalogue, which

role, in a world approaching the Orwellian threshold of 1984, the artist would play; would it be 'statesman/politician/jester'?[120] Topics addressed and documents printed in the catalogue included the latest criminal justice bill for Scotland and discussion on penal reform, a section on nuclear power, sustainable transport proposals from Lucas shop stewards, and a section on the Brandt Report about disparities in wealth between the northern and southern hemispheres and the role global trade could play in rectifying these. All were subjects of exhibitions and discussions organised as part of the Free International University. Another instance of this breadth of interest was when Demarco, knowing Beuys's interest in ecology, sent him a copy in 1973 of Ernst Schumacher's influential and newly published book of essays, *Small is Beautiful*.[121]

In this spirit the Black and White Oil Conference was held between 19 and 21 August 1974. In many ways, the speakers Beuys and Fuller had complementary viewpoints, both holding passionately to the belief in mankind's intelligence evolving with and through a profound knowledge and respect for nature. Each, too, was well known for holding long lectures; Fuller since his contributions in the late 1940s at Black Mountain College in North Carolina, Beuys since his period as a teacher at the Düsseldorf Academy.[122] Oil had been discovered in the North Sea in 1969. By 1974 half of all the oil in the UK sector of the North Sea had been located. Added urgency in planning for its commercial exploitation was given by the worldwide recession resulting from the sudden increase in oil prices by OPEC during 1973. As a consequence of this energy crisis Western nations and oil companies were searching for alternative sources to reduce dependency on oil from the Middle East. It was not until 1977 that the platforms and pipelines were built, to bring these huge discoveries under the North Sea to the market place. Production increased substantially in the late 1970s. The year 1974, then, following the discovery but before large-scale extraction, represented a critical juncture in discussions about the impact an oil industry would have on Scotland. *New Beginnings are in the Offing* 1981 is a print-multiple Beuys made about this nascent industry.[123] It is a photograph of Beuys taken in 1974, holding a newspaper with the headline 'The First of the Giants', while standing in front of a bronze statue of a dog. With irony and good humour, Beuys challenged the newspaper headline, which referred to the first of the gigantic deep-sea oil platforms then being erected in the North Sea, by asserting that not they but the dog was in fact the first of the giants. The statue, erected in Edinburgh in 1873, commemorates the loyalty of a pet dog, a Skye terrier called Greyfriars Bobby, which faithfully guarded the grave of its dead master until its own death fourteen years later. This presented Beuys with another example of the animal instinct, an intuitive intelligence that shapes the relationship between humans and animals.

The debates about oil broadened to include demands for Scotland to control its own industry. Since lack of devolution meant that Scottish affairs were governed by the Scottish Office in Westminster, the discovery of this valuable resource led to increased demands for greater autonomy over Scottish affairs. This debate over Scottish nationalism also embraced a desire to control revenue. As Willie McNeill argued, 'Scotland is being exploited for its oil to get the South East out of its financial mess.'[124] Arguments presented at the conference also

addressed the broader issues of energy generation, from renewable sources to the effects of the nuclear power industry, then also in the ascendancy in Britain. One major cause for disquiet in Scotland was the sheer unexpectedness of the oil discoveries. One view expressed in the conference leaflet was that decisions taken then would affect Scotland for the next fifty years; these were therefore necessary and pressing issues. Scotland was the last place on earth expecting to become an oil state: the effect on its culture as much as its economy and ecology was at stake, particularly in the speed and scale of the development of the Scottish oil industry on the east coast, around Aberdeen. Commenting on the complexity of the issues, the conference leaflet concluded, 'By ironic coincidence, the Gaelic word "oil" means "a cause for regret".'[125]

THE FORREST HILL POORHOUSE

JOSEPH BEUYS

The overall tone at the conference, however, was not defensive or oppositional. The organisers viewed the forum as a unique form of experiment in communication. Not for its subject matter, which was widely discussed at the time, but more for the mix of participants: 'Over the three days it lasts, the show will present many views on what oil means to Scotland – the view of the poet as well as that of the planner, the view of the artisan as well as that of the artist.'[126] The evening session on the second day, for example, was billed as a poets' evening. Other sessions were structured so that different viewpoints were juxtaposed. There was a morning session in which Hugh Sharman, whose presentation on 20 August was published a fortnight later in *Resurgence* magazine, was followed by a representative of the oil industry. Sharman spoke about using the discovery of oil to tilt the economy towards post-industrialism. Under those conditions, he wrote, 'technology will be soft, non-exploitative. Power sources will be solar, wind or hydrobased'.[127] Moving beyond the industrial era of 'multinational corporations, huge government departments and the car factories' was necessary, he argued, 'to ensure the long term

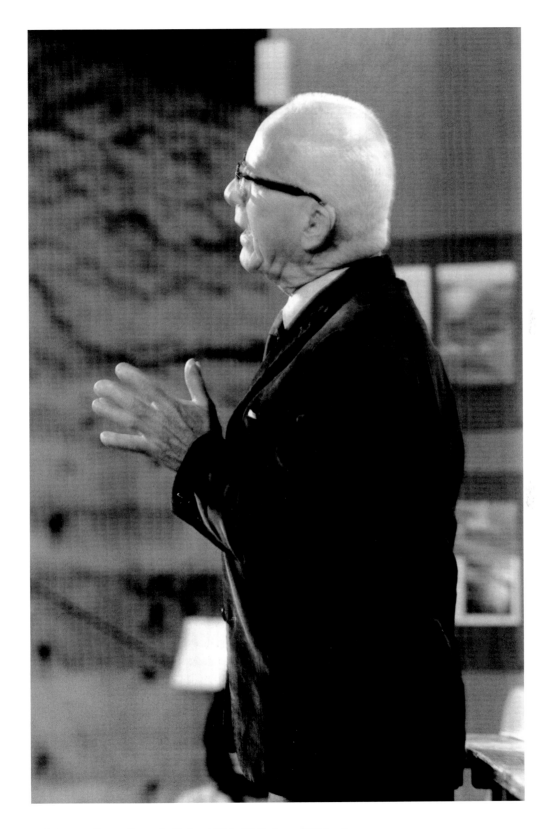

Buckminster Fuller speaking at the Black and White Oil Conference, Edinburgh, 1974.

survival of the human species within the biosphere'.[128] This ran counter to the messages from the politicians present. Although praised for appearing at the conference, Gavin Strang MP and his counterpart from the Scottish National Party were both criticised by Neil Oram, the Scottish farmer-poet, whose report of the proceedings is one of the few records of the event.[129] Arguing over the destination of oil revenues, Oram concluded that the polished arguments of the politicians were without wisdom and did not relate to the situation of the people.

A different note was soon sounded when the artist Gerald Laing commented that it was important to consider the state of consciousness. This, Oram recorded, 'was an astonishing beginning to a conference on oil. It set the tone for the next three days.'[130] This was certainly true of the contributions of Buckminster Fuller and Beuys. Fuller spoke during the afternoon of the first day, with Beuys following the same evening. The international attention attracted by the conference is confirmed by a telegram from Indira Gandhi, then Indian Prime Minister, conveyed to the conference by Raymond Foulk and Lauri Say of the World Resources Education Trust. She praised Fuller 'for his endeavour to understand what science and man can do for one another. He so clearly sees unity amidst specialization that he can dismiss the pervasive feeling that technology is a tool of destruction. He reassures us that man can triumph over shortcomings for the mind and spirit are man's greatest resources.'[131]

Following on from Laing's opening comments, Fuller pursued a similar tack, discussing the history of humankind's decision-making, carefully differentiating between 'mind and brain, between mere obsession and thinking'.[132] Ownership of the oil and control over decisions to exploit it were key issues, argued Fuller. He pointed out that the planet could in the following decade radically decrease its dependency on fossil or nuclear fuels for energy generation in favour of replaceable resources. He viewed politicians as the major stumbling-block to this realignment of energy policy. Fuller's final message was to integrate humans in the ecology of the earth, 'to realise that we are part of one organism – the planet in vast space'.[133] Beuys's contribution, a three-hour lecture, echoed Fuller's sentiments. Like Fuller, he stressed the importance of individual liberty while relating developments in the oil industry to wider issues in the development of Western consciousness. 'Both he and Fuller demonstrated,' reported Oram, 'the creation and bringing through of spiritual energy by thinking with their whole being on the spot, inviting us to take part in the creation of living human sculpture.'[134] To commemorate the event, both Fuller and Beuys were the subject, along with Lady Rosebery, of a photographic multiple Beuys produced for the Demarco Gallery in 1980.[135]

As the 1980s progressed, the main arena for Beuys's activities in Britain became his frequent exhibitions in London. He maintained ties to his many friends and colleagues in both Britain and Ireland, though, attending the 1984 ROSC exhibition, *The Poetry of Vision*, in Dublin organised by Dorothy Walker, for example, where a group of his drawings were shown. He also travelled to Kilkenny in south-eastern Ireland to view Richard Long's exhibition at Kilkenny Castle.[136] Around the same time he returned to Oxford at the invitation of the Oxford

Union, for another experience of the city a decade after he had shown *Secret Block* ... there. It also meant an opportunity to visit again the Pitt Rivers museum, one of his favourite in England. As with his trip to Limerick in the 1970s, where his fame had yet to penetrate, Beuys found in Oxford an audience completely unaware of his achievements, in spite of memories of his drawing show there in 1974 and a more recent drawings exhibition that travelled widely around Britain during 1983 and 1984. According to Roland Rudd, President of the Union that year, the intended invitee, Petra Kelly of the German Green Party, resisted repeated attempts to secure her presence and proposed instead Beuys, who was then still a high-profile member of the Green Party, as a substitute. Beuys, Rudd recalled, while a dramatic presence in his gamekeeper's gilet at the black-tie dinner and subsequent debate, was unknown to most of the Oxford undergraduates, who had been expecting Kelly, at that time frequently in the news. Nor would he stick to the arcane rules governing the debate, which called for a short speech followed by questions where the speaker could choose to give way, or not, to voices from the floor.[137]

Beuys's engagement with Britain and Ireland, as this incident demonstrates, embraced many aspects of his art and life, and was mediated and supported by many committed friends and admirers. His activities ranged from the traditional exhibition of artworks to a concerted attempt through frequent lectures and dialogues to engage a wider audience in his ideas about direct democracy and creative capital. In the German Idealist tradition, he saw the need for artists to be positive agents of transformation in the development of a more equal society. His fascination for the lands of King Arthur and Celtic mythology was enriched by other artists he met in Edinburgh and tempered by an equal desire to address the social ills of the day – from the challenges of the oil industry to the iniquities of the penal system. His use of language as a tool for creating and disseminating his ideas, as much as for shared etymologies and as an expression of humour, was enriched by the creative freedoms he saw exemplified in the writings of Joyce. He remained in close contact with Demarco, Tisdall and others in Britain until the end of his life. His final meetings with Demarco, in late 1985, were at the opening of *German Art in the Twentieth Century: Painting and Sculpture 1905–85* at the Royal Academy and *Plight* at the Anthony d'Offay Gallery. Two weeks before he died, Beuys phoned Demarco to say he had been invited by Douglas Hall, Director of the Scottish National Gallery of Modern Art, to mount a retrospective there. 'I love Scotland. I am coming. This is the reason,' he told Demarco in the last conversation they had.[138] Beuys's presence in these islands on the western rim of the European mainland was clearly more vital to the development of his art than emerges in the histories of the period.

Joseph Beuys, *Bits and Pieces* 1957–85

Caroline Tisdall in Conversation with Sean Rainbird, 2001

SEAN RAINBIRD: *Is there a single work in the* Bits and Pieces *collection that has an especial importance for you?*

CAROLINE TISDALL: There are many themes running through the collection; lots about alchemy, humour, about plants and the transformation of energy. *Interconnecting Vases* [*Two Vases with Precious Water* 1975][1] is probably one of the definitive images in this collection. It was made with blood and insulin, when Beuys was in hospital in 1975 following his heart attack. He was having treatment in Düsseldorf before he went to the spa in Bad Rothenfelde.

SR: *So it commemorates a private event, when his health was endangered and he was physically at his most vulnerable?*

CT: It is a symbol of love, friendship and reciprocity. 'C' and 'D' [Cosmas and Damian] with the cross, the triangle and, at the bottom 'J' and 'C', which could be Joseph and Caroline. The triangle is usually a Trinity symbol. In all my earlier writings, I must confess I rather suppressed the Christian angle, but should acknowledge it more now. We did talk a lot about it. Fundamental to his work was the transformation of material and I think you almost have to be brought up a Catholic to use that as a creative principle.

I am a Celt and a total pagan. We often talked about spirituality. By the 1980s he was certainly not a practising Catholic. He was very annoyed with the Pope's visit to Ireland [September–October 1979], the huge turnout and all the conservative things the Pope represented. But there were many elements of Catholicism he kept, like the reincarnation of souls. He also had some fundamental ideas about death and what it means as a destination. In this collection, on an ironic level, is the *Hat for Next Time* [1974].[2] After his encounter with the Dalai Lama in 1975 he was very attracted, in later life, to Buddhism. It led to the Amsterdam conference Art meets Science some years later.

It shows in his work with Nam June Paik – particularly the works with the flame. It wasn't exclusively a Buddhist flame though; think of his saying '*schütze die Flamme*' (guard the flame). That connects to German philosophy and produces echoes in different cultures. He was confident talking about things which were

very difficult to talk about or even taboo: *Braunkreuz* ['brown cross', the distinctive brown pigment Beuys used], the German oak. He felt himself to have grown up in a Catholic, Celtic enclave [in Cleves]. The Lower Rhine is a strange spiritual place, literally quite cut off from Germany like a bend in the river.

SR: *What part does language play in this?*

CT: He was very deeply rooted in the German language. His whole idea of rehabilitating Germanic imagery and symbols was because he felt that any country which cannot look at its own history is built on foundations of sand and will turn more and more to modern materialism which completely denies spirituality. He felt that was really dangerous not only because of materialism, but also because of a backlash; politically, a spin back into neo-Nazism. One so wishes he had been there when Germany was reunified [in 1989] and the whole spiritual vacuum was exposed, comparing the legacy of both forms of materialism: capitalist materialism and de-spiritualised, grey, Eastern materialism.

SR: *Do these sentiments come to a head in any place in Germany you visited, or in any symbolic taboos he confronted?*

CT: We went to Externstein in 1975 when he was still recovering from his heart attack. It was a day trip to an absolute taboo place, as it was one of Hitler's shrines to the Germanic spirit. All the Germanic gods were meant to be there; one of those fat fertility goddesses was dug up there. He wanted his photograph taken with his hand over his heart. What came out was a de-politicised image. It was tongue-in-cheek but like an oath-swearing gesture. He had the confidence to do that. Just like the *7000 Oaks* project [1982, Kassel] which was growing in his mind at the time. The oak is the symbol that you find on the Iron Cross [a military decoration]. The Nazis had really tried to subsume it into their hierarchy of symbols. As Beuys always said, it is terrible to deny the 'oakness' of your countryside just because of the Nazis. If you do that, you deny your own culture, your own history. In *Bits and Pieces*, the earliest work is an oak-leaf drawing from 1957, a collage, the earliest I have ever seen [*Untitled*].³ I think it is an incredible drawing, so perfect. It has his old-fashioned signature, the early sort, on the bottom right.

SR: *Can his use of* Braunkreuz *be viewed in the light of your comments about national identity?*

CT: The same does go for that brown colour. That terrible Nazi thing of 'blood and earth' [*Blut und Boden*]. He actually dared to take materials like that and use them, and he reinstalled them in the canon of their 'Germanness'.

SR: *Presumably the colour and its material presence in his work also refers to excrement and chocolate?*

CT: Yes, but for a German they are dangerously close to *Blut und Boden*. One noticed in Germany during the 1970s that they could hardly talk about this.

SR: *But some co-opted symbols, such as the swastika, never appear in Beuys's work.*

CT: He would never have used the swastika. He was talking about restoring things

pre- and post-swastika. The swastika was never in his canon. It's a sun symbol and he had his own sun symbol. To sanitise the swastika: I don't know if even Beuys could have done that.

SR: *I have always been intrigued by his use of Gothic script at certain points in his career.*

CR: Gothic script has its own history. If we were German we would feel sad it fell out of use because of the Nazis. Beuys wanted to undermine the misuses and reappropriate the sources. You have to remember Heinrich Böll too, doing a huge examination of the German spirit in his writing, in books like *The Lost Honour of Katharina Blum* and *Faces of a Clown.*

SR: *How well did they know one another?*

CT: Beuys's friendship with Böll was very significant. You can follow it through the decades. Böll always used to apologise for being boring! Beuys always had difficulty reading his work, of getting beyond Chapter One. They knew each other well enough for him to feel how it went on after that. The Organisation for Direct Democracy through Referendum and the Free International University for Interdisciplinary Research [FIU] were both collaborations with Heinrich Böll. It was great for Beuys to have a kindred spirit like that on his level, and vice versa. After Böll died there was Günter Grass, but Grass was a German Socialist, associated with a political party, not a free spirit like Heinrich Böll who was important for me too, and encouraged my writing.

SR: *Let's talk about* Bits and Pieces. *How did it begin and when and how did the first objects arrive?*

CT: We were in Berlin at a conference and he offered me a choice of some drawings he had with him. I chose a drawing from 1973 [*Untitled*][4] which has a dam with water pouring over it. Energy piling up, like water behind a dam, and flowing smoothly over. It has this wonderful gauze filter in the corner; all the principles of his Theory of Sculpture are here. I have tried to decipher the repeated word many times, but cannot. At the top is a drawing of the wedge principle with things flowing over it, like the dam.

SR: *The idea of two elements changing and charging each other?*

CT: Yes. Then there are the three curving elements, another wedge and the elements that come back on themselves, like his 'Eurasian Staff' concept, where energy flows out and comes back again. It's wonderful how one can go on finding and interpreting things in one drawing.

SR: *At what point did he intimate that he was building a collection for you. Or did it become obvious over time that this was happening?*

CT: That's a very interesting question. I've never thought about it. Everything with Beuys happened in such a natural way, but I imagine that by the time whole sets of things came, like the four botanical drawings *Rosemary, Calendula (Marigold), Nasturtium, Pomegranate* [all 1975],[5] he was obviously building up something. Rosemary is obviously for remembrance. And he was very fond of my

mother, who was a Shakespearean actress in her younger days. And I was born in Stratford-upon-Avon. So rosemary features in the botanical things. Then calendula, which is an incredibly important homoeopathic plant. When he sent it it was an amazing orange, like the sun. When he was at school and the Nazis were burning books, he tried to save a number of them from the fire, which probably wasn't the safest thing to do in those days. But one of the books he saved was Linnaeus. And I think he wondered about that until the end of his life; why Linnaeus had been thrown on the fire.

The collection reflects pretty accurately what was going on while it was being formed. He then actually suggested exhibiting it, and we showed it at Paul Neagu's Generative Art Gallery in 1976. By then it already had its main themes: its Celtic and botanic themes, its mystical theme, alchemy and politics. The other thing there from the beginning was his interest in language: plays on words and the examinations of puns, differences between languages and curious things about English. Like the riddle in *Three Hares* 1975:[6] '*Drei Hasen und die Ohren drei und doch hat jeder seiner zwei*' (if there are three hares and three ears, how can each hare have two ears?).

SR: *There are some references to England and the English, but Beuys had a greater sympathy for the Celts, didn't he?*

CT: That's right. Apart from the lecture at the Tate [in 1972] and my showing of *Secret Block* at the ICA [1974] and the ICA's German month [*Art into Society – Society into Art*, September–October 1974] when he made *Directional Forces* (*Richtkräfte*), he didn't work much in England. There was much more interest in Scotland because of Ricky Demarco, and in Ireland because of the FIU.

SR: *Presumably a lot of this activity was connected to projects you were involved with, arranged, or wrote about?*

CT: Yes, and landscapes we travelled through to do that. The bogs of Ireland, North America, Italy.

SR: *Is this similar to the origins of the groups of work assembled by Beuys for other friends and collectors?*

CT: Not to the same extent. None are as personal as this one. Because I was interested in botany, history and language I think he was able to expand its content. We had an ongoing botanical dialogue through all the years, because in my little garden in Brixton I used to grow about 350 different species, not as a pretty garden, but as plant specimens. I used to bring them back from all over the world and every month I sent him a list called 'Blooming in Brixton' of everything that was flowering at that time. And he would send back things from his little backyard in Düsseldorf, or his garden in Holland. I said somewhere, somewhat mischievously, that art is never mentioned in this collection. And in the original catalogue for *Secret Block for a Secret Person in Ireland* [Oxford 1974], he said: 'There, we haven't even mentioned art', and 'If I have to talk about art, I feel quite tired!'

SR: *But a lot of very practical things are mentioned, aren't they?*

CT: The thing that is unique about the collection is the light it throws on the non-object-based side of his work. I was very interested in the FIU and the political side of the organisation. You get a very good combination of objects, drawings and ideas in *Bits and Pieces*. I cannot think of any other collection where that is so well displayed. It would be a tragedy for Beuys's work if the form were to be divorced from the ideas. No one can own the ideas. As they are transitory they risk being forgotten.

SR: *What strikes me is that it is a very practical lexicon, not a set of instructions, but a densely planted approach to someone's art. You can read a lot of these objects very directly.*

CT: Absolutely. It gives you the homoeopathic, the herbal, Rudolf Steiner, bio-dynamics, concerns with nature as a whole, the environment, the imbalance of the spirit and material. These run through the whole block.

SR: *He seemed to have a special gift of allowing a small object to speak volumes about complex issues and projects.*

CT: Take the bandage, for instance, issued to German soldiers during the war [*Untitled* 1977].[7] If you put that in a vitrine it becomes monumental; it gives you the theme of the war and a whole phase of his autobiography, and in signing such an object, he claimed its whole history.

SR: *There are a lot of autobiographical objects in the collection, aren't there?*

CT: You see the whole idea of felt and fat, obviously, but also toe-nails, which is a shamanistic theme [*Fossil* 1975].[8] He cut something off himself and gave it to someone as a gesture of great trust. Then he brought it into comical realms by saying that is how he made his pocket money, which was true, because he always needed ready cash to support his political activity. First the Organisation for Direct Democracy, then the Free International University; they needed endless support.

SR: *Is that why he made an increasing number of multiples in the latter part of his career?*

CT: Absolutely, to generate revenue and spread ideas at the same time. The same with the *fonds*. It's a wonderful idea, a play on words: a fund or reserve. Many of his works are energy-generative. Nearly all these objects are batteries of energy, like the peat, coke and coal, all with Irish Kerrygold butter, which make up the *Irish Energies* [1974].[9] From the start they were included in *Bits and Pieces* and there has obviously been a fantastic reaction between some of the different materials, like the butter going rancid and brittle. The *Fat Corner* [1979][10] is a wonderful way of describing geometry and free flow; the theory of sculpture. You have the butter in a right angle, like the cornerstone of Western architecture, and the butter flows out of it in liquid form. With the olive oil in the other box you think you would never see anything, but it has left an incredible residue, saturating the whole box over the years.

SR: *The boots* [Sulphur Boots][11] *also have this connection with process, don't they? They also introduce the idea of duality and doubling.*

CT: Well, we do have two feet! Beuys was fascinated with earth's energy fields, and the way we move across its surface: hence the alchemical sulphur in and on the soles of the boots – the boots in which he performed *Coyote* [May 1974, René Block Gallery, New York]. The double image goes through the whole collection. The most wonderful image of doubling he ever made was *Show Your Wound* (*Zeige Deine Wunde*) 1976, in Munich. But it is a theme of this collection, which ends with the amazing double stag skulls [*Butter Pots* 1983].¹² Then again he is able to introduce the gracefulness of humour, calling them 'butter pots'; domestic items – 'use it'. He was contemplating his own end, but still had a sense of humour to draw on.

SR: *Speaking of practical things, the group of Guggenheim working sketches¹³ seems to me to give an insight into one of the greatest exhibitions he ever made [it ran from November 1979 to January 1980], and which you curated.*

CT: They are very scientific. They were made a year before the exhibition while we were preparing the book. I went regularly to his studio in Düsseldorf. We'd sit down and talk through the exhibition station by station, chapter by chapter. It was a fantastic opportunity to go through the whole work. The book, as you know, is pretty well verbatim what he said. The sketches come from notebooks of the time.

SR: *So these small sketches give a look behind the scenes?*

CT: Yes, '*ein normaler Arbeitsplatz mit einigen merkwürdigen Zutaten*'. He wanted the Guggenheim to be like 'a normal workplace with a few remarkable additions'. He wanted very early 'Wedges' in the show, from the late 1940s, one propped on the other like the Sulphur Boots here, or the Welsh Nut piece of coal under the peat briquette [*Irish Energies* 1974].¹⁴ And how to use those famous Guggenheim ramps? Of course we found this very radical solution, bringing in all those tons of Tallow [from the exhibition *Unschlitt/Tallow*, Munich 1977] by taking off part of the façade, the load-bearing bit, of Frank Lloyd Wright's building. Beuys could be very challenging to institutions!

SR: *The sketches include one entitled* dummer Hammer mitnehmen [*1979*].¹⁵

CT: 'Take your silly hammer with you'. It was always the thing to do. Don't be scuppered if the institution isn't prepared. Boy Scouts.

SR: *You have referred several times to moments of comedy or humour in* Bits and Pieces. *How important were they to Beuys?*

CT: You can trace humour through everything. Take the boots, which have sulphur on their soles and inside. It has to do with how you move across the surface of the earth. He had a great thing about skates and how they move you across the earth – iron on ice – and had this fascination with girl skaters. For him this was a very erotic image and he made lots of drawings of women on skates. This pair of almost teddy-bear boots in which he padded around for years have sulphur on them, which raises them up to the level of something mysterious.

I find that kind of constellation very amusing. It is the spirit in which it is intended. Like the *Hat for Next Time* [1974],[16] which is so tragi-comic.

Most of his works are, in one way or another, autobiographical, or refer to his experience. I cannot think of any of the big works that don't. That was his canon. The whole point of the idea 'everyone an artist' is that you are your own biography and spirituality is a microcosm of what's outside. Multiples, for instance, carry ideas to a lot of people. His idea was if you made a point of entry, people might carry on following the ideas. If someone owned a multiple, they had a stake in the whole business. What I did observe is that people from outside the art world had no trouble at all relating and they weren't frightened of Beuys and his work, as many art-world people were. I'm thinking of the craftsmen and technicians who helped install *Tramstop* in Venice in 1976, who were perfectly in tune with the work. A hole into the lagoon – 'yes' – to the surface of the earth – 'oh yes'. Never seen a tramstop in their lives, coming from Venice. Bombshells from Germany –'oh yes, wonderful, bella, bella' – and let's have a great party to inaugurate it.

Shall we look at more of the amusing things? The *Samurai Sword* [1974][17] is a humorous object for different reasons. It's a tiny little thing with huge pretensions. A little bit of dried sausage, beautifully cut along its blade to be a samurai sword. It's a powerful object.

SR: *Why did he include it?*

CT: Partly because in his geography he needed a couple of anchors in Eastern points. He described the energy flows that cross West/East, and the energies that cross Eurasia. The samurai sword is a symbol of a terrible sort of energy, but the physical process of making samurai swords is remarkable: a process of heating and beating, reheating and beating. The changes in molecules through this continuous tempering are remarkable. Obviously there is an echo in Beuys's work of fat flowing in different forms. Then there is the terrible purpose a samurai sword is used for.

Why do I find it humorous in Beuys's terms? It relates to those other works with a knife blade wrapped up in the bandage and the idea that if you cut yourself you should bandage the knife. It leads you back into a discussion about Steiner and homoeopathy, 'healing like with like'. I am sure the fat in the wurst – very much a wurst not a salami! – is significant. He made this incredibly delicately; it's actually got an angled edge on the blade side of it.

SR: Coyote [1974] *was an action you were very involved with. The photographs you took are the ones everyone uses. In a sense its inclusion in* Bits and Pieces *points up the connection to you. It is one of those moments that make the collection so personal. Beuys doesn't claim back* Coyote. *He gives it the reference, in the form of the* Wall Street Journal [1974][18] *and you're handed the platform as the recipient of* Bits and Pieces, *but also active participant – like with the* Battery [1974],[19] *which consists of a pile of* Guardian *newspapers, for which you were art correspondent at the time.*

CT: That's true. He was always extremely gracious like that, never possessive about ideas, and able to acknowledge input by others.

SR: *I sense the object consisting of a rock crystal and mirror shard* [Untitled *1979*][20] *is connected to the installation* dernier espace avec introspecteur [*1982*], *another of the works which refers to installations you were closely involved with or wrote about.*

CT: That's right. It speaks of mountains and glaciers, one of those monumental objects which you can hold in your hand. The rock crystal is very autobiographical, with the hexagon forms from the cooling of the earth, and with all the mysticism of crystals and mirrors. In a way I think you are right; a lot of the gifts were acknowledging assistance and writing; in other works a contribution, which he never underplayed and which is very unusual with artists!

SR: *This idea of collaboration is carried through by references to Cosmas and Damian, Beuys's nicknames, now gruesomely topical, for the twin towers of the World Trade Centre in New York* [Postcard: Cosmas and Damian *1974*],[21] *but also in the object* Cosmas and Damian with Dicentra *1975*.[22]

CT: Cosmas and Damian are very interesting because they were the two constant companions who travelled round the world healing. They were rather mischievous, so there was something autobiographical in that. They came across a sick white person with an ulcerous leg and substituted it with the leg of a dead Moor. Beuys was very perceptive about the humour in the lives of the saints. He often referred to them, of course, Ignatius Loyola and people like that. Cosmas and Damian were the letters 'CD' he often put with 'JC' because we were travelling around together – doing our best for the world.

SR: *There is an accent on natural colour through the presence in that drawing and elsewhere of dried plants. But there isn't otherwise a strong sense of colour in* Bits and Pieces, *with the odd exception such as the drawing made with grey pigment with the centre cut out* [Untitled *1960*].[23]

CT: He used grey to emphasise the colour around in the world; grey felt and grey pigment. *Untitled* 1960[24] is one of the earliest works in the collection, possibly the first one of the grey drawings he made. It has echoes later on in the multiples [*Painting Version 1–90 1976*][25] and in the book of what he called *Sheep's Heads* [*Painting Version 1–90 1976*].[26] The small drawing is absolutely monumental. In terms of looking beyond Beuys to other artists, you could think of Lucio Fontana and the spatialism of his paintings. It's an interesting link because one does tend to view Beuys hermetically, not in the context of European art of the time. In Beuys's drawing is a sense of the positive/negative contrast, a shadow of another presence, which also recurs in other works in the collection, such as *Northern Irish Tongue* [1974].[27] There is one multiple where his head is cut out [*Three Ton Edition 1973*, inscribed 'sheeps head' by the artist in blue ink].[28]

SR: *Why did he print on* PVC *for this edition?*

CT: He was excited by the technical development of silkscreen on PVC, a wonderful, heavy, floppy material which holds the silkscreen printing well. There are forty different images in different combinations, printed on the front and back. Most have brown pigment painted over the images. I think he put them into the

collection to cover a lot of ground from past actions. The sledges are in there from *The Pack* 1969 [*Das Rudel*]. *The Pack* is one of my favourite works. It's so brilliant – the idea of what to do when technology runs out.

SR: *Was there a sense of rounding off the collection by sending you* Capri Battery [*1984*]?[29]

CT: Beuys didn't give me that. It was given by [the Italian dealer] Lucio Amelio when I was making a film after Beuys's death. I had been making a film while he was still alive and the BBC asked me to finish it. Lucio came and was filmed in my house in London talking about it and about *Palazzo Regale* 1985, and he gave me that multiple. Wenzel [Beuys, the artist's son] gave me the receipt for the *7000 Oaks* certificate. One of the last works from Beuys was the *Ein-Stein-Time* [*Einsteinzeit* 1984].[30] We tried to meet in October the year before he died. I couldn't come down from Scotland to meet him although he knew he was on the way out. We had had a terrible, tragic fire in which two people died, and I couldn't leave while this was being investigated. So we talked on the phone, and he left me with the *Butter Pots*.

SR: *Did you ever discuss how* Bits and Pieces *was displayed? You've made a series of vitrines for it, but it hasn't always been shown this way.*

CT: In the Generative Art Gallery in 1976 the objects just sat on shelves, but there was someone in the room all the time. I suppose one has to admit things go into vitrines because they become precious objects.

SR: *Vitrines also give a sense of coherence, don't they?*

CT: My instinct was to show in the order the works were given, in the different categories: objects, drawings, multiples. I've always shown it like that. If you try to do it by theme, that works too. It has sometimes been shown by subject: the medical bits, the botanical bits etc., but I don't think you could impose that order on the whole. I put them back into the order of the date they were made, which mostly follows the date they were given. Things he made in the Seventies were given then. When he gave earlier things I put them before the things he gave at the time he made them. Then there were clear themes from the time we were working, like the *Secret Block* installation or the Guggenheim show. We installed *Bits and Pieces* together once, then it was lent in bits to the Irish Bank. They installed it and sent it back in a whiskey box to Archbishop Place in Brixton. I wasn't in so they left it with a neighbour and it kicked around for months before I saw it again. We were incredibly casual at that time. Another time pieces went over to Ireland, to be shown in one of the annual ROSC shows contrasting contemporary art with Celtic objects. That time it came back in a box and kicked around with an Irish artist. The only exhibition we were never able to do was the James Joyce, Beuys and Richard Hamilton *Ulysses* drawings, which is a great shame. The owner of the Beuys drawings was anxious about the conditions in the exhibition space and wouldn't lend. It was a pity because the exhibition would have opened on Bloom's Day in 1977, and would have been an historic event.

SR: *One of the vitrines contains several sketches, some of the smallest in* Bits and Pieces, *which show other unrealised installations or projects.*

CT: There are several drawings with oscillating forms [including *Untitled* 1975].[31] I think he should have made a big environment with these things. They are very elusive; there is something of the same feeling in the sketch for the Tate environment [1975].[32] But I know that would have been made of felt. There was going to be a floor piece and a suspended element. Neither the cairns and dolmens sketch [1974][33] on a Lufthansa ticket nor the environment in the sketch on a matchbox glued underneath the ticket were made [1974].[34] What a loss for the Tate! He showed up with this proposal and felt he'd been turned down. *Only One Line* 1975[35] is, again, a tiny sketch, but has those swinging elements. It was only in the last part of Beuys's life that he was able to do the big environments and really only if there was a patron. He didn't deal with large [commercial] galleries until the 1980s. As you know, he always supported outsiders, like Demarco.

SR: *We've spoken about the funny moments that run through the collection. Talking of being on the outside, one work that always makes me smile is the poster and postcard multiple* Democracy is Merry *[1973],[36] with those words written over a photograph of Beuys being removed from the Düsseldorf Academy of Art in 1973.*

CT: It's even funnier in German. '*Demokratie ist lustig*'; so wonderfully banal. I was looking at the photo again today, at his and his students' faces all looking incredibly naughty, and the rather stern-looking policemen. Johannes Rau was then a state minister; he went on to became a federal minister and is now the Federal President. I can hear Beuys laughing. When it happened Rau made an embarrassing TV statement in the most clipped, bureaucratic German, about how Beuys was '*fristlos entlassen*' – 'dismissed with immediate effect' – for defying restricted access to his course at the Düsseldorf Academy.

　　Going on with the funny things: *Afrika* [1974][37] has an elastic band for the equator; it has now slipped down. It makes me laugh. I recognise the shape of Africa, but sometimes those kinds of objects are very mysterious to me. That must be the difference between familiarity and coming across them later. So many of these objects are *objets trouvés* – 'magnetic rubbish' – which is my definition of Beuys's work [refers to *Magnetischer Abfall* 1975],[38] intended to attract and intrigue people into new ideas and energies, like a magnet, or a Pied Piper.

SR: *I've also been looking at the admonition in the James Joyce book* [James Joyce: and now six further chapters are needed *1977*].[39]

CT: I was meant to finish it, hence the dedication, to go on writing the great novel which I still haven't written, which Böll urged me to do as well. It's very personal and I would be sad to say goodbye to that object.

SR: *Would you prefer to keep it?*

CT: I shouldn't get into that. All or nothing, don't you think?

Notes

PAGES 11–77

1. In spite of a disinclination to create an outdoor sculpture garden, Tate Director Nicholas Serota explored with Beuys's widow Eva the possibility of extending the artist's *7000 Oaks* project to London by siting a series of oak trees coupled with half-buried basalt blocks around the grounds of Tate Modern. Sadly, the idea came to nothing.

2. In fact, posters for the exhibition at its venues in Dublin and London, in Caroline Tisdall's archive, both dated the drawings from 1948 (not 1936) to 1972.

3. Conversation between Anne and Anthony d'Offay and the author, 20 Oct. 2004.

4. Monique Beudert and Sean Rainbird (eds.), 'Julian Schnabel' (interviewed), in *Contemporary Art: The Janet Wolfson de Botton Gift*, exh. cat., Tate Gallery, London 1996, p.96.

5. A three-way ceasefire in January 1973, which recognised a North Vietnamese supremacy, allowed America a way out. However, fighting continued between North and South Vietnam until Saigon fell to North Vietnam on 30 April 1975.

6. In particular, Willoughby Sharp, 'An Interview with Joseph Beuys', in *Artforum*, Dec. 1969, pp.40–7; Alistair McKintosh, 'Beuys in Edinburgh', in *Art and Artists*, vol.6, 1970, p.10; George Jappe, 'A Joseph Beuys Primer', in *Studio International*, vol.183, no.936, Sept.1971, p.65; John Anthony Thwaites, 'The Ambiguity of Joseph Beuys' and Alistair McKintosh, 'Proteus in Düsseldorf', both in *Art and Artists*, vol.6, no.7, 1971, pp.22–6.

7. A small group of sketches relating to the exhibition are in *Bits and Pieces*. See *Bits and Pieces: A Collection of Work by Joseph Beuys From 1957–1985, Assembled by Him for Caroline Tisdall*, exh. cat. by Caroline Tisdall, Richard Demarco Gallery, Edinburgh 1987, pp.33–4, cat. 116–23.

8. There are few exceptions to this, one being the discussion about *Directional Forces* 1974–7 and the 1972 Tate lecture, in Barbara Lange, *Joseph Beuys: Richtkräfte einer neuen Gesellschaft*, Berlin 1999, pp.197–234.

9. Conversation between Bakewell and the author, 23 Sept. 2004.

10. Stüttgen is shortly to publish a detailed account of the *Celtic…* action.

11. Many of those asked by the author about their recollections vividly recalled his charismatic presence, without retaining any detailed memories of the events they witnessed. These include the filmmaker John Wyver (who saw the 1972 event at the Tate Gallery) and the critic Adrian Searle (who attended the 1974 talk at the Museum of Modern Art, Oxford).

12. Poster advertising 'Joseph Beuys: I like America and America likes me. Documentation of a performance at the René Block Gallery New York, May 1974' at Forrest Hill, Edinburgh, 19 Aug.–7 Sept., private collection, on loan to Tate.

13. Conversation between McDowell and the author, 18 Oct. 2004.

14. See Wenzel Beuys, trans., 'Interview between Joseph Beuys and Richard Hamilton', in Eva, Wenzel and Jessyka Beuys, *Joseph Beuys Block Beuys*, Munich and London 1997, pp.7–16, transcript of an interview broadcast on the BBC, 27 Feb. 1972.

15. Richard Hamilton, 'Joseph Beuys (1921–1986)', in *Art Monthly*, no.94, March 1986, p.11.

16. Albrecht D, Joseph Beuys, K. P. Brehmer, Hans Haacke, Dieter Hacker and Klaus Staeck were in both shows; Siegfried Neuenhausen and Wolf Vostell showed only in Hanover; Gustav Metzger only in London.

17. Conversation between Rosenthal and the author, 20 Oct. 2004. Rosenthal accompanied them through the exhibition. Margaret Thatcher was famously unresponsive to avant-garde art.

18. Dieter Koepplin, *Joseph Beuys: The Secret Block for a Secret Person in Ireland*, Munich and New York 1988, pl.433.

19. Richard Demarco Gallery, Edinburgh 1987, pp.24-5.

20. Guy Brett, *The Times*, 29 Feb. 1972.

21. The full blackboard text is quoted in *The Tate Gallery 1984–1986: Illustrated Catalogue of Acquisitions*, London 1988, pp.491, 494. The Tate lecture-action is discussed in depth in Lange 1999, pp.220-38.

22. Conversation between Serota and the author, 22 Sept. 2004.

23. Ibid.

24. Conversation between Tisdall and the author, 25 Oct. 2004.

25. Conversation between Anne and Anthony d'Offay and the author, 20 Oct. 2004. Anthony d'Offay was successful in bringing Beuys and Sylvester together, and engaging Sylvester's interest in more recent artists than Bacon, Giacometti and Magritte, with whom he was profoundly identified. When the Pompidou acquired *Plight* in 1989, the credit line records the support of Anthony d'Offay and David Sylvester, in memory of the artist. Sylvester wrote about his friendship with Beuys and his assessment of the German as an artist in 'On Beuys – Sculptor Joseph Beuys, Dia Center, New York, New York', in *Art in America*, April 1999, pp.114-17.

26. Conversation between Anne and Anthony d'Offay and the author, 20 Oct. 2004. There is clearly a personal significance not only in the choice of Beuys for the inaugural exhibition but also that the show opened on 12 August 1980, which was coincidentally Anne d'Offay's birthday and the d'Offays' wedding anniversary. Alongside the *Stripes ...* ensemble at the newly opened gallery at 23 Dering Street, d'Offay also showed some objects and drawings at his existing premises at 9 Dering Street.

27. Conversation between Tisdall and the author, 25 Oct. 2004.

28. Conversation between Adam and the author, 15 July 2003.

29. Conversation between Serota and the author, 22 Sept. 2004.

30. See entry, by the author, in *The Tate Gallery 1984–1986* 1988, pp.96-8.

31. He visited the Republic of Ireland in late September to give lectures, and went to Belfast shortly before the exhibition closed, in late November. Dorothy Walker, in her memoir on Beuys, records an unexpected reminder of this later visit, when she viewed the Warhol sale in New York in 1988 and came upon one of Warhol's Beuys items, a page from Beuys's diary dated 24 September 1974, with 'Dublin' written diagonally across it. In Dorothy Walker, 'Joseph Beuys and Ireland 1974-1984', 28 Oct. 1992, unpublished manuscript [n.p.] (copy in Tate Gallery Records).

32. Rosenthal recalls Beuys turning up promptly at noon and staying until the galleries closed at 8 p.m. without leaving the space. When he was out of the gallery because of previous commitments, he would leave a note on one of the blackboards. See illustrations in Christos M. Joachimides, *Joseph Beuys Richtkräfte*, Nationalgalerie, Berlin, 1977, pp.37, 51. On the last day of the show Beuys dedicated and presented a newly drawn blackboard to Rosenthal; see illustration in ibid. p.53.

33. Conversation between Rosenthal and the author, 20 Oct. 2004. A press notice issued on 29 Nov. 1974, after the exhibition had ended, recorded that Beuys had used seventy-seven blackboards in London. He used others to expand the work when it was seen in New York. See Ingeborg Karst (ed.), *Der Fall Staeck*, Göttingen 1975, p.29. This volume was published to document the subsequent furore in Germany triggered by a German Conservative politician's visit to the exhibition, at which he took offence at (the very modest amount of) German public money being used to support a project, which included Klaus Staeck's satirical posters against the CDU/CSU parties. The main cause of offence was Staeck's 1972 poster lampooning the Christian Socialist Union, with an image of the Bavarian premier Franz Josef Strauss sharpening his knives under the heading '*Entmannt alle Wüstlinge!*' (castrate all debauchers).

34. See Lynne Cooke and Karen Kelly (eds.), *Joseph Beuys: Where would I have got if I had been Intelligent!*, New York 1994.

35. Cooke, 'Installing "Arena": An Introduction', in ibid. p.12.

36. Richard Demarco to Jennifer Gough-Cooper, letter dated 31 Jan. 1970, Scottish Gallery of Modern Art Archive, GMA A37/1/0563.

37. The show was co-selected by Caroline Tisdall and the artist Timothy Emlyn Jones, himself included in the exhibition. Letter to the author from Emlyn Jones, 13 Sept. 2004.

38. Quoted in Caroline Tisdall, *Joseph Beuys: We Go This Way*, London 1998, p.88.

39. Conversation between Anne and Anthony d'Offay and the author, 20 Oct. 2004.

40. Penninus appears in various manifestations in *Secret Block for a Secret Person in Ireland*: as a personification of the deity in *Penninus* 1964, no.390; in two drawings as the *Astronomy of Penninus*, both 1976, nos. 451–2; and in mineral form in two drawings made with metallic paints, *Penninus Place*, both 1976, nos. 455–6, in Koepplin 1988.

41. Koepplin 1988, pl.64.

42. The artist, quoted in Caroline Tisdall, *Joseph Beuys*, exh. cat., Solomon R. Guggenheim Museum, New York, 1979, p.62. See also the Penninus drawings in *Secret Block …* in Koepplin 1988, pls.390, 451, 452, 455, 456.

43. Koepplin 1988, pl.374.

44. See Richard Demarco Gallery, Edinburgh 1987, pp.7–8.

45. Walker 1992.

46. Ibid.

47. The CAIN, University of Ulster, website records a mural at the mill depicting the 1982 committee, but records too that the artists had painted a portrait of Father Des Wilson.

48. John Latham, 'Joseph Beuys (1921–1986)', in *Art Monthly*, no.94, March 1986, p.10.

49. Ivan Illich, *Deschooling Society*, New York and London 1973, p.9.

50. Walker 1992.

51. Ibid.

52. Conversation between McDowell and the author, 18 Oct. 2004. McDowell assisted Beuys in the winter of 1974–5 when he was invited to Hamburg to teach at the art academy there. A couple of years later Beuys invited McDowell to become his primary assistant, a role eventually filled by Heiner Bastian.

53. Caroline Tisdall, 'Report to the European Economic Community on the Feasibility of Founding a "Free International University for Creativity and Interdisciplinary Research" in Dublin', Dublin and London 1975, section 2.3.

54. Ibid., section 2.5.

55. Conversation between Marriott and the author, 27 Sept. 2004.

56. See Jörg Schellmann, *Joseph Beuys Die Multiples: Werkverzeichnis der Auflagenobjekte und Druckgraphik*, revised ed., Munich and New York 1992, pls.372, 495, pp.297, 368.

57. Richard Hamilton in *Art Monthly*, no.94, March 1986, p.11.

58. Conversation between Anne and Anthony d'Offay and the author, 20 Oct. 2004.

59. Related to the author by McDowell; conversation, 18 Oct. 2004.

60. Richard Hamilton, *Work in Progress*, Orchard Gallery, Derry 1988, quoted in Stephen Snoddy, 'Yes … & No', in *Richard Hamilton*, exh. cat., Tate Gallery, London 1992, p.50.

61. For further discussion of the Beuys/Joyce link, see Sabine Fabo, *Joyce and Beuys: ein intermedialer Dialog*, Heidelberg 1997; Christa-Maria Lerm Hayes, *James Joyce als Inspirationsquelle für Joseph Beuys*, Hildesheim, Zurich and New York 2001; Christa-Maria Lerm Hayes, *Joyce in Art: Visual Art Inspired by James Joyce*, exh. cat., Dublin 2004.

62. Walker 1992.

63. Exhibition at the Picker Gallery, Kingston University. See Demarco's text, written in July 1974, in *Edinburgh Festival 1974: Edinburgh Arts Exhibitions and Events*, Richard Demarco Gallery, Edinburgh 1974 [n.p.].

64. In an interview with the author on 25 June 2004, Demarco recalled Beuys's presence at a lecture on Meikle Seggie he gave at the Kunsthalle Düsseldorf in 1978.

65. Illustrated in Uwe M. Schneede, *Joseph Beuys: Die Aktionen*, Stuttgart 1994, p.266.

66. See Demarco's Introduction in Richard Demarco Gallery, Edinburgh 1987, p.2; *Beuys; Klein; Rothko*, exh. cat., Anthony d'Offay Gallery, London 1987, pl.3, pp.36–7.

67. Richard Demarco Gallery, Edinburgh 1987, nos.4–7, pp.4–5.

68. The exhibition was *Vitrines: Forms of the Sixties*, Anthony d'Offay Gallery, London 1983.

69. See Schneede 1994, p.266.

70. According to Schneede, Beuys organised three barrels of gelatine to be sent to Karlsruhe where he was in an exhibition. However, he did not use the materials and they were later sent on to Edinburgh, see Schneede 1994, p.267. Sandy Nairne, who assisted Demarco in 1973, recalled Beuys's down-to-earth practicality and straightforwardness when asking for materials. Conversation with the author, 13 Sept. 2004.

71. Richard Demarco, *Joseph Beuys: A Tribute on Rannoch Moor – 27 September 1986*, brochure, quoted in Schneede 1994, p.267.

72. The importance of gelatine to the action is demonstrated by its inclusion, bottled, in the multiple *Celtic +* ∿∿∿ Beuys made in 1971. The work otherwise includes a Super 8 film of the action and ten photographs. See Schellmann 1992, no.37, pp.78–9.

73. Conversation between Stüttgen and the author, 15 Sept. 2004.

74. Susan and Alexander Maris, letter to the author, 6 Sept. 2004. There are photographs in the Demarco Archive of Beuys and Demarco looking out over what Demarco describes as the 'ill-advised afforestation' of Loch Awe side. Another photograph, showing a single tree in an otherwise treeless landscape, has been captioned by Demarco: 'Joseph Beuys happy to see at least one indigenous tree still standing as a rebuke to the artificial forest being planted around it.'

75. Solomon R. Guggenheim Museum, New York 1980, p.10.

76. Conversation between Johannes Stüttgen and the author, 15 Sept. 2004.

77. Liam de Paor, 'The Art of the Celtic Peoples', in Robert O'Driscoll (ed.), *The Celtic Consciousness*, Edinburgh 1982, p.121.

78. Ibid.

79. Richard Demarco Gallery, Edinburgh 1987, no.58, pp.22–3.

80. O'Driscoll 1982, p.xi.

81. Christopher Bamford, 'The Heritage of Celtic Christianity: Ecology and Holiness', in O'Driscoll 1982, p.169.

82. Quoted in ibid.

83. Ibid.

84. Ibid., p.175.

85. Ibid., p.174.

86. Walker 1992.

87. Koepplin 1988, pl.35.

88. Demarco to Firth, letter of 11 May 1970, Scottish National Gallery of Modern Art Archive, GMA A 37/1/0563.

89. Hagen Lieberknecht, 'Auszüge aus einem längeren Tonbandinterview vom 29 September 1970 zwischen Joseph Beuys und Hagen Lieberknecht, geschrieben von Joseph Beuys', in *Joseph Beuys: Zeichnungnen 1947–59*, Cologne 1972, quoted in Schneede 1994, p.267 (author translation).

90. See David Bellman (ed.), *A Journey from Haga Qim to the Ring of Brodgar*, Richard Demarco Gallery, Edinburgh 1976.

91. Frank Ashton-Gwatkin, 'A Survey of History', in ibid. p.12.

92. See Bellman 1976, pp.13–14, 80–1, 87, 96–8, 174–6.

93. See Armin Zweite and Bernd Finkeldey, *Joseph Beuys: Werke aus der Sammlung Ulbricht*, Cologne 1993, pl.46, p.123.

94. A fish, unconnected with the double circle and 'Z' bar motif, features prominently on the Craw Stane Stone at Rhynie. Two of the Pictish stones at the wayside and in the churchyard at Aberlemno, both with double circles bisected by 'Z' bars, are illustrated in Bellman 1976, p.176. One of the Aberlemno images is also prominently illustrated in Richard Demarco, *The Artist as Explorer*, Edinburgh 1978, p.36.

95. Gerhard Theewen, *Joseph Beuys Die Vitrinen: Ein Verzeichnis*, Cologne 1993, p.85.

96. See Jennifer Gough-Cooper, 'News Sheet No.9', Richard Demarco Gallery, May 1970.

97. See the black and white photograph of the artist, his wife Eva Wurm-Beuys and their children Wenzel and Jessyka, both wearing kilts, during the installation of *Arena* in Edinburgh, in Cooke and Kelly 1994, p.39.

98. Conversation between Nairne and the author, 25 June 2004.

99. Letter from Tremlett to Demarco undated (probably June 1970), Scottish National Gallery of Modern Art Archive, GMA A 37/1/0369.

100. Richard Demarco, 'Three Pots for the Poorhouse', in *Joseph Beuys: The Revolution is Us*, exh. cat., Tate Liverpool 1993–4, p.13.

101. Quoted in Schneede 1994, p.355.

102. See Demarco's obituary of Paul Neagu, the *Scotsman*, 2 Aug. 2004.

103. Quoted in ibid.

104. See Demarco, 'To Frank Ashton-Gwatkin', in Bellman 1976, pp.4–5.

105. Tisdall 1998, p.72.

106. Illustrated in Richard Demarco Gallery, Edinburgh 1987, pp.24–5.

107. Koepplin 1988, pls.444, 445.

108. Illustrated in *Joseph Beuys: Natur Materie Form*, exh. cat., Kunstsammlung Nordrhein-Westfalen, Düsseldorf 1991–2, p.22. The drawing is undated. Since Beuys first visited Newgrange only in 1974, a later dating might be more likely. This suggestion is strengthened when one considers that Richard Demarco used both spiral motifs on the cover of Bellman 1976, published by Demarco's gallery.

109. See illustrations in Joachimides 1977, p.25.

110. Anish Kapoor's obituary of Paul Neagu, *Guardian*, 28 June 2004.

111. Ibid.

112. Jimmy Boyle, 'Extracts from Thoughts', in *Jimmy Boyle Exhibition of Sculpture*, exh. cat., ICA London, June 1975 [n.p.]. Quoted text dated Dec. 1974.

113. Demarco to Beuys, letter dated 13 Dec. 1975, Scottish National Gallery of Modern Art Archive, GMA A37/1/0980.

114. Press statement dated 5 Sept. 1980, Scottish National Gallery of Modern Art Archive, GMA A37/1/0797.

115. The drawings are illustrated in Richard Demarco Gallery, Edinburgh 1987, pp.28–9.

116. See Beuys to Demarco, letter dated 8 May 1980, Scottish National Gallery of Modern Art Archive, GMA A37/1/0981.

117. Sherri Irvin, see www.canadacouncil.ca/prizes/ggvma

118. Conversation between Bakewell and the author, 23 Sept. 2004.

119. See Georg Jappe to Demarco, letter dated 18 July 1970, Scottish National Gallery of Modern Art Archive, GMA A37/1/0563, in which Jappe expresses his exasperation with the lack of funds from Scotland supporting *Strategy: Get Arts*: 'You remember that Scottish people are known in the world only by anecdotes of their avarice. It is absolutely impossible that Düsseldorf contributes about 4300 pounds, the Ambassy [*sic*] 1000 pounds and the whole Scotland only 1000 pounds … These artists are emancipated and don't depend on one exhibition.'

120. George Fraser, 'The Artist as Statesman', in *Avant Garde Art: What's Going Up in the 80s*, exh. cat., Richard Demarco Gallery, Edinburgh 1980 [n.p.].

121. See Demarco to Beuys, letter dated 19 April 1973, Scottish National Gallery of Modern Art Archive, GMA A37/1/0984.

122. See Martin Duberman, *Black Mountain: An Exploration in Community*, New York and London 1972, pp.295–6.

123. Schellmann 1992, no.371, p.296.

124. Information sheet on the conference, Scottish National Gallery of Modern Art Archive, GMA A37/1/0551.

125. Ibid.

126. Ibid.

127. Typescript of Sharman's speech, in ibid.

128. Ibid.

129. Evidently a tape recording was made; see the postscript in a letter of 1 Aug. 1975 from Tisdall to Demarco, asking him to send a transcript of the tapes to Beuys; Scottish National Gallery of Modern Art Archive, GMA A37/1/0980.

130. Neil Oram, Report on the Black and White Oil Conference, unpublished typescript, Scottish National Gallery of Modern Art Archive, GMA A37/1/0551.

131. Telegram of 20 Aug. 1974 to the Chairman of the Black and White Oil Conference with a message from Indira Gandhi, Scottish National Gallery of Modern Art Archive, GMA A37/1/0551.

132. Neil Oram, Report on the Black and White Oil Conference, unpublished typescript, Scottish National Gallery of Modern Art Archive, GMA A37/1/0551.

133. Ibid.

134. Ibid.

135. See Schellmann 1992, no.366, p.294.

136. Walker 1992.

137. Conversation between Rudd and the author, 16 Sept. 2004.

138. Conversation between Demarco and the author, 25 June 2004.

Index